the 3rd &4th HERE'S HOW

COMBINED EDITION

EASTMAN KODAK COMPANY
ROCHESTER, NEW YORK 14650

CONTENTS

© EASTMAN KODAK COMPANY, 1975
Standard Book Number: 0-87985-152-X
Library of Congress Catalog Number: 75-7722

Dr. Grant Haist, FPSA, FRPS, is a Research Associate in the Kodak Research Laboratories, where he deals with unconventional photographic systems. Grant devotes his spare time to making exhibition photographs, lecturing, and writing about photography. He is a 5-star exhibitor and has had more than 1,500 prints exhibited in international salons. His pictures have appeared in national magazines and have won prizes in many contests, including 13 consecutive annual awards from the Freedoms Foundation.

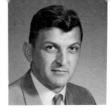

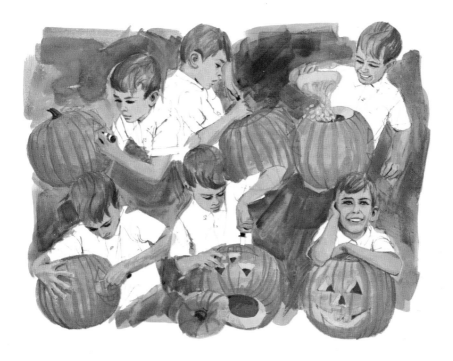

PHOTOGRAPHING CHILDREN NATURALLY

by Grant Haist

Babies and children are the most photographed of all picture subjects. Only photography provides an enduring record of the continuing growth and the varied activities of the very young. Because intimate picture records of babies and children become more precious, indeed priceless, as time passes, you should take each new photograph with the utmost care to insure the very best portrayal of childhood. Surprisingly, you can take an outstanding child photograph almost as easily as you can a casual snapshot. But you must combine a knowledge of child psychology with a definite camera-handling approach to achieve this goal.

1

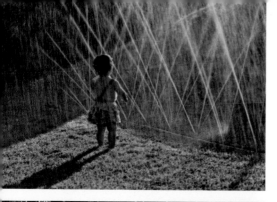

The child's unawareness of the photographer in this backlighted scene produced a candid and striking picture. You can get pictures like this in your own backyard by sitting on a lawn chair near where the child is playing, and grabbing your camera for an eventful moment like this one.

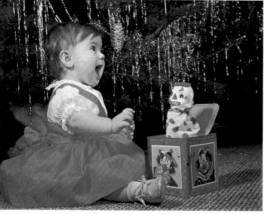

Give a gift to a very young child; then photograph the action that results. Be sure to have all photographic preparations made before the gift is presented so that you can get a complete picture series from the moment that the child first sees the gift.

Capturing Natural Expressions

Successful child photography involves nothing more than capturing on film the spirit of childhood. Almost all pictures of infants have this natural quality. Babies are unaware of the camera as they are pictured during the normal course of their daily routine. But as children reach about four or five years of age, they become acutely conscious of the presence of the camera. Stereotyped poses and expressions usually replace the normal youthful interests. Too often, the photograph shows this induced artificiality. Only after the shutter has been released and the camera put away does the child's naturalness return.

Most children are hopeless in responding to posing directions. Asking a child to pose in a specified way invariably results in a loss of naturalness. The young and eager often overact in their effort to please. Some may respond with a lackadaisical, let's-get-it-over-with-quickly attitude. Attempting to correct these attitudes generally produces an even less satisfactory response. So, unless a gifted child model is avail-

able, you should refrain from specific posing directions, as the results are usually less than desirable.

But if a child is enjoying an activity of his own choosing, the natural enthusiasm that he shows will be recorded on the film without the need for any posing instructions. The normal progression of the activity will insure many opportunities for picture-taking that will be superior to those situations that might have been contrived. The unplanned and the unexpected provide chances for capturing an exceptional photograph. Your objective should be catching the fleeting expression or the momentary situation rather than attempting to direct the action.

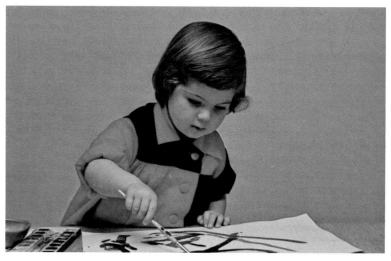

Your children are usually not aware of the camera when they're busy doing something. The photographer took this natural-looking picture while the girl was working on her "masterpiece."

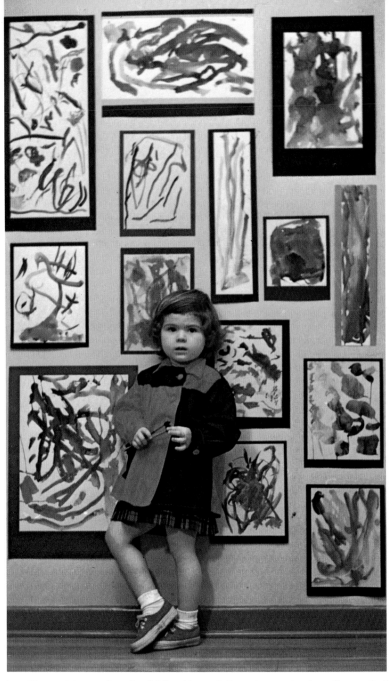

In taking a picture series of a child making paintings, be sure to show the result of the activity. This may require you to set up a final picture, as was done here.

The Picture-Series Method

The method that I use to photograph a child of camera-conscious age involves selecting an activity that the child is known to enjoy, such as listening to a bedtime story or playing in a pool of water. Then I plan a number of photographs to tell the complete picture story of the event. But the picture-series method can also be used if only a single photograph near the end of the activity is wanted. The child should be allowed to enjoy himself from the beginning rather than be instructed to start with a preconceived pose that might be part of the later action. Film exposures are made from the beginning also, so that picture-taking becomes part of the activity. If you follow the picture-series approach, you will have a storytelling set of photographs, the most striking of which can be used as an outstanding single photo.

The picture series should show a complete story; the first photograph sets the scene, followed by several others of the continuing action, and with a final picture that satisfactorily concludes the activity. The opening photograph should show the child or children and all essential props in detail. This establishes the location of the activity, but be careful to see that the backgrounds are simple and compatible with the story to be pictured. The following photographs of the series may be close-ups, especially of facial expressions. Catch any action at its peak intensity. The final photograph should complete the story by showing the logical result of the previous activity. Sometimes a logical ending may not be suggested, so an illogical one, especially if humorous, may do just as well.

Finding Picture Opportunities

Episodes suitable for making a picture series are truly infinite in number. Everything that a child does during his waking hours is a new adventure in the continuing story of childhood. You should observe this great variety of daily activities for situations that might be suitable for a picture series. And be sure to write down immediately any picture possibility, because chance observations are often difficult to remember at a later time.

Most children will repeat an enjoyable activity, so pictures may be taken at that time. But you need not limit your picture opportunities to situations that can be repeated. You can create new diversions by using gifts to provide the interest that brings out the most animation in a child. For example, giving an artistically inclined girl a set of finger paints would provide the situation for picturing the modern artist at

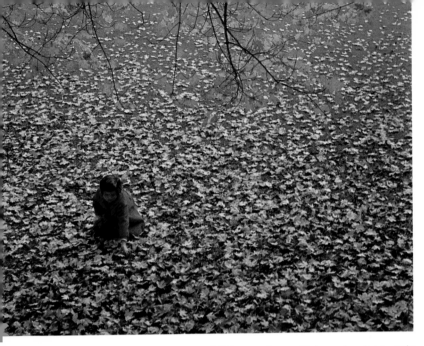

There are many picture-series possibilities outdoors. High-angle views make common scenes more interesting.

Try to select activities that involve lots of action for a picture series. Use the sun as the main light, with fill-in flash to light the shadow areas.

work. Or presenting a pumpkin to a boy could result in a how-to-do-it series on decorating the Halloween jack-o'-lantern.

You should make all photographic preparations before the presentation of the gift. The first time the child sees the gift will be the time of maximum enthusiasm. This is the time to get a complete set of pictures. The child's interest will be diminished the second or third time the gift is used, although such repeat sessions can be photographically productive. However, the child may exhibit much less animation than occurred the first time.

Unfortunately, some situations pass by so quickly that all the desired film exposures cannot be made. One year, my very young daughter had a new birthday cake presented to her on three different days. This allowed me to use a different type of film on each occasion so that I might have color transparencies, color negatives, and black-and-white negatives available. Surprisingly, cake frosting did not lose its appeal, even on the third occasion.

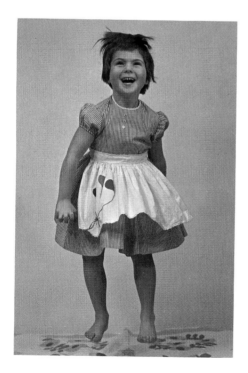

Select activities in which the child can show off her abilities, such as bouncing on the bed. Here, bounce-flash lighting was used in a dimly lighted room. A weak fill-in light was near the camera.

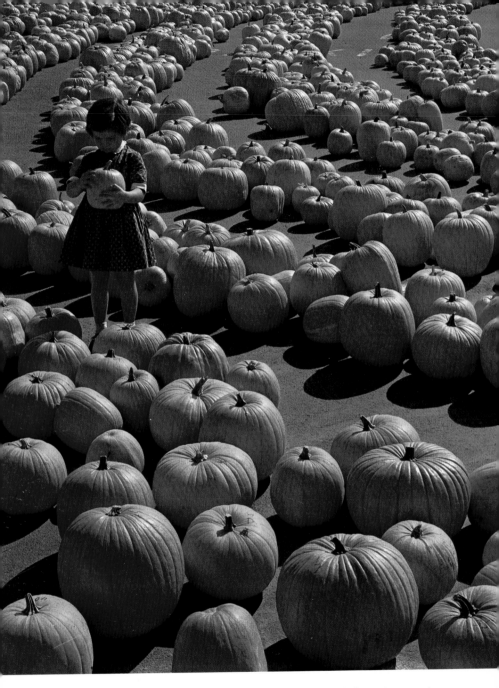

Many events connected with holidays can serve as the basis for a picture series. Such a series is valuable as a record of the child as well as having the added appeal of a holiday occasion.

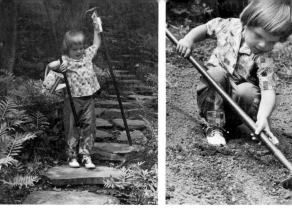
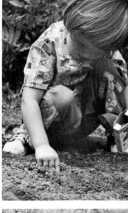
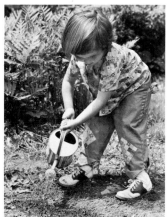
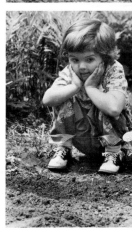

The picture series should begin with a photograph that sets the scene for the activity, followed by a number of pictures showing the ensuing action, and ending with a picture that concludes the story in a satisfactory manner.

Planning the Picture Series

Getting a complete set of pictures at one time will require some planning. You should visualize how the activity might begin and then form a fairly definite conception of the content of the first picture of the series. By arranging the conditions at the very start of an activity, you can cause the desired situation to occur without asking the child to pose. You do not need to plan for the pictures that follow the first one—just be ready to capture the unexpected. The concluding picture of the series may be the one that requires some direction from you if a desired ending has been visualized, but the child may spontaneously provide a logical conclusion without any interference.

The picture-series method of showing the high points of a normal and unrestricted activity allows you to plan and to record a number of pictures to tell a story. This is better than waiting and straining to catch a decisive moment that may never occur. However, your picture series will also contain the supreme peak of activity that did happen. This can be used as a single picture. But you will find that the entire set

of pictures is more effective, since each picture contributes to the completeness of the story. And, given a choice, most persons will find the series more enjoyable than the single photograph.

Photography and fun will become associated in the mind of a child who is allowed to enjoy himself while the camera is present. Future photographic sessions will be welcomed by the youngster. But you should carry the psychology of securing child cooperation at least one step further. Photographic modeling is a paid profession, regardless of the age of the model, and you should reward your young models as a regular practice. A small reward, such as a favorite candy bar, a small toy, or a picture book, should be given immediately after the last shutter click. If the reward is always given immediately, without fail, the taking of photographs becomes associated with a most pleasant experience, thus ensuring the child's favorable attitude the next picture-making time.

Working with an Assistant

A happy, animated child is the first requirement for outstanding child photography. But there are still many discordant details that may mar the finished photograph. An assistant is invaluable for detecting and correcting many of these deficiencies, thus freeing the photographer's attention for the selection of the best possible picture composition or for catching a fleeting highlight of action. The child's mother can often provide such help by keeping stray wisps of hair in place, smoothing wrinkles from clothing, or, in the case of an infant, providing other necessary services. A regular assistant, who has become familiar with your own particular working methods, is the most efficient.

During the actual time of film exposure, your assistant should be near, or even slightly behind, you. Two moving persons, widely separated, provide a divided source of attraction for the child's attention. Sometimes happy expressions can be coaxed from a tired or self-conscious child by having your assistant engage in a pantomime behind your back, such as a clown-like attempt to hit you on the head with any available object. Crazy antics should be used sparingly and only as a desperation measure for totally unresponsive children.

Securing Adequate Lighting

Photography of children under conditions of only slight control makes more difficult the problem of obtaining sufficient lighting. Outdoors, use a reflector or fill-in flash near the camera, with the sun behind the picture subject, to secure good facial rendition. The sun provides the

backlight to help separate the subject from the background. This is especially important for pictures of children with dark hair that might blend into a shaded or tree-filled background.

Rapid-recycling electronic flash is also an excellent source of fill-in lighting for outdoor use. Regular or improvised reflectors permit you to observe just how much light is being directed into the shadows. Reflectors are especially useful with cameras having focal-plane shutters. The high shutter speeds needed to stop action of children at play won't synchronize with electronic flash in a focal-plane camera, so reflectors may be used to supply the necessary lighting.

Indoors, use bounce flash to give a soft, even illumination that is both natural-appearing and effective over a wide area. To give a sparkling highlight to the eyes, use a weak fill-in flash at or near the camera. But you will have to determine by test the correct exposure for the bounce lighting under the actual conditions of use. Starting at about twice the normal exposure for direct flash, take a series of exposures that includes pictures with both greater and lesser exposure than the estimated exposure. Using a color-slide film, such as KODACHROME 25 Film (Daylight), for the test exposures will aid you in selecting the correct exposure and also determine whether bounce lighting in that room will give color casts on the film. Be sure to record the exact placement of the lights, the camera and subject location, the lens settings, and all other important information. Even better, write the details down before making the exposures. I often sketch a map of the floor arrangement with the distances marked and the height of the lights noted. It's amazing how much you can forget by the time the processed film is available for study.

The diffused lighting given by bounced flash produces a feeling of softness that is characteristic of childhood. However, you may wish to have pictures that show maximum detail and texture. Direct flash gives this type of rendition. For best results, use at least two lighting units: one for the off-camera main light, the other for the fill-in light on or near the camera. The two-light triangle lighting arrangement avoids the overly dark shadows and the flat lighting given by a single source of light near the camera. Cameras with a permanently attached flash unit may be used to trigger a slave lighting unit at some distance away. A non-wired slave unit can supply the main source of off-camera light, with the on-camera flash being used as the fill light. An electronic flash with two flash heads can be used for the same lighting arrangement.

(See "Have Flash, Will Travel," page 31.) Place the stronger off-camera light so that the illumination will come from the direction in which the child is facing. But shadow areas should be well illuminated, too, just in case the child does not look in the anticipated direction.

Some Helpful Techniques

Photograph the Child's Possessions—Tell the child that you want to take a photograph of her doll or favorite stuffed toy, or of his block house or sand castle, but do not mention taking the child's picture at the same time. Children are much less self-conscious if you are photographing their possessions, even though they are in the picture, too. You can stage a birthday party for a child's favorite doll, and then invite the child to attend. Dolls have birthdays too, you know!

Use a Flash Decoy—Some of the younger children will smile wondrously at the light from a flashbulb after the picture has been taken. If you observe any amazement on the part of the child to a flash, have an extra hand-triggered flashgun available. Flash this gun first, and then when the child reacts, take the picture with the regular lights. Surprisingly, the flash decoy can be used to relax over-tensed adults but usually it is good for only one picture with the grown-ups.

Photograph from the Child's Level—Lower the level of your camera so that it is even with the child's eyes or lower. Children, especially those just beginning to walk, live in a world of huge furniture and giant adults. By photographing from a low level you can show some of the child's perspective in your photographs. You can also picture some of the difficulties of the small child as he attempts to cope with his gigantic surroundings, such as the problem of climbing into a chair.

Children are best photographed in the security of their own home or in the familiar surroundings where they are the most relaxed. The illustrations show my daughter Lynne Ann under such conditions. But providing a child with an interesting diversion will permit you to photograph anywhere. When children have fun, they forget the immediate surroundings, even though these may be strange. Some professional photographers have adopted a walkaround technique of child portraiture in which the film exposures are made as the unrestricted child is allowed to investigate a number of play areas in the same bounce-lighted studio. By photographing children naturally, at home or away, you can capture the spirit of youth with a series of film exposures. The picture-series method will give not just one picture but the entire story for all to enjoy.

Robert S. Harris is a well-known lecturer, teacher, judge, and author on the subject of photography. Bob directs photo teams for Eastman Kodak Company's multimedia productions on assignments that have taken him to more than 20 countries. He has appeared on a variety of TV talk shows and has hosted a series on Educational Television called "Taking Better Pictures." For his participation in photographic exhibitions and competitions, he has won more than 100 medals, trophies, and other awards. In 1967, the Photographic Society of America listed Bob as the world's top color-slide exhibitor.

"PUSHING" *KODAK* HIGH SPEED *EKTACHROME* FILM by *Robert S. Harris*

Introduction

For decades photographers have attempted to increase the effective speed of color films by "push" processing. This has always led to sacrifices in quality that in the past were fairly severe. The speed of KODAK High Speed EKTACHROME Film can be increased at least 2½ times. To increase the film speed, see page 21. This increased speed allows you to use faster shutter speeds, smaller lens openings, or a combination of both. This, in turn, permits you to take color photographs in very dim light or to stop action in fast-moving sporting events.

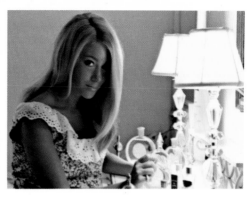

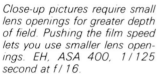

Close-up pictures require small lens openings for greater depth of field. Pushing the film speed lets you use smaller lens openings. EH, ASA 400, 1/125 second at f/16.

Available light from the lamps was used to photograph this girl. EHB, ASA 320, 1/30 second at f/2.8.

Your flash pictures can be taken at greater distances, or with smaller flashbulbs without a change in your guide number.

Let's discuss some situations where this extra speed will be useful. Then we will discuss the processing modifications that more than double the speed of High Speed EKTACHROME Film.

Depth of Field

Small maximum apertures are characteristic of some telephoto lenses and lens converters. Smaller apertures can also be very desirable with your regular lenses for obtaining maximum depth of field. Depth of field becomes shallower as the degree of magnification becomes larger.

Let's say you want to photograph a small bug so that it is nearly life-size on your film. You can accomplish this with a long-focal-length lens, or you can move in closer with your regular lens. In either case, your depth of field will be very limited and a fast film will allow you to use smaller apertures and obtain better depth of field.

Existing Light

High-speed films and "fast" lenses make it easy to take pictures in existing daylight or artificial light indoors. Existing light produces natural-looking pictures and is often more pleasing than other types of lighting. Since you are usually shooting at wide apertures, it is important to focus critically. Pay special attention to holding your camera steady, and for shutter speeds longer than 1/30 second, use a camera support. The Existing-Light Exposure Dial in the *KODAK Master Photoguide* will give you a starting point for your exposure. See your photo dealer for a copy of the *KODAK Master Photoguide*, KODAK Publication No. AR-21.

14

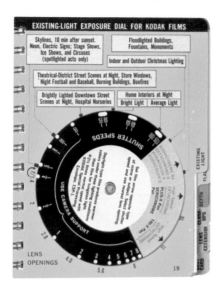

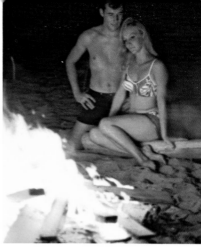

Watch out for the misleading influences of glaring lights, like this fire, or dark surroundings when using an exposure meter. EHB, ASA 320, 1/30 second at f/2.

Existing-Light Pictures

There are two types of High Speed EKTACHROME Film—Daylight type for use in daylight, and Tungsten for use with artificial illumination. When you plan to make natural- or existing-light photographs under tungsten-type lights, use the Tungsten film.

Let's go to a wedding. This is a wonderful opportunity to practice your natural-light photography. Bring your meter instead of your flashgun, and you will find your subjects far more willing to be photographed. Most clergy have restrictions on flash photography in the church, but there are few objections to existing-light photographs. Most folks won't even realize that you are taking pictures, especially if you can muffle the click of the shutter with church music, singing, or oratory. If you would like to get a close-up of the actual ring ceremony, be sure to get clerical approval before the ceremony to take pictures through a side door to the altar. Maintain your unobtrusive photographic manner by keeping out of the audience's sight and by using an 80 mm to 135 mm lens through the door to "get in close" to the ceremony.

High Speed EKTACHROME Film (Tungsten) pushed to a speed of ASA 320 is adequate for most weddings. An f/2 aperture on your 35 mm camera might be adequate in a dimly lighted church, but rely on your meter for precise exposures. After the church service, when everyone steps outside, it's time to slip on an 85B filter to continue your wedding coverage in daylight. Remember, the speed of the pushed Tungsten film drops from 320 to 200 when the 85B filter is used over the lens for daylight shots. Events are pretty fast-moving once outside the church, and you may want to rely on a basic bright-sunlight exposure of 1/250

second at between $f/11$ and $f/16$. Now you're set for the bride and groom dashing through the rice shower to their car. If you want to photograph the happy couple in the car, jump into the front, open your aperture about 4 f-stops, and take a shot of the bride and groom close together in the back seat. Whoops! Don't forget to allow for parallax for those close distances of about three feet.

There are many other indoor situations that require the speed of pushed High Speed EKTACHROME Film (Tungsten). They include basketball, bowling, swimming, hockey, stage productions, the circus, ice shows, boxing, political events, pageants, and a variety of ceremonies. Your meter and a good knowledge of its use are important in this sort of photography.

If you can get a close-up reading of the actual subjects you're shooting, fine. But if your meter "sees" large areas of surrounding darkness, your pictures will be overexposed by the readings the meter gives. Bright floodlights shining into the meter will bias your readings in the other direction. Assuming a film speed of 320, a typical night exposure at a big-city ball park will be about 1/125 second at $f/2.8$. If your meter suggests an exposure much different from that, it's probably being "fooled" by extraneous factors.

Action Pictures

Let's go to the races—any races—people, dogs, horses, boats, cars and cycles. They all have one thing in common—speed. Some photographers prefer to represent speed by using slow shutter speeds and controlled panning to produce blurred images on the film. This is fairly difficult and requires considerable experience to perfect.

The surest way to succeed in handling speed photography is with speed—a speedy film, a fast shutter speed, speedy reflexes, and panning. Panning is the technique of following the motion of the subject with the camera. This is similar to the way a hunter follows the flight of a duck with his shotgun. Panning will result in the sharp reproduction of the subject you are following while blurring the background. If you don't pan, remember that action travelling at right angles to the camera is hardest to "stop." Diagonal movement and movement toward or away from the camera are easier to stop. Also, the farther the action is from you, the easier it is to stop, because the relative image movement on the film is less. The best way to stop any action is to use the fastest shutter speed you can under the prevailing lighting conditions.

In some action shots, you can pick the peak of the motion as the

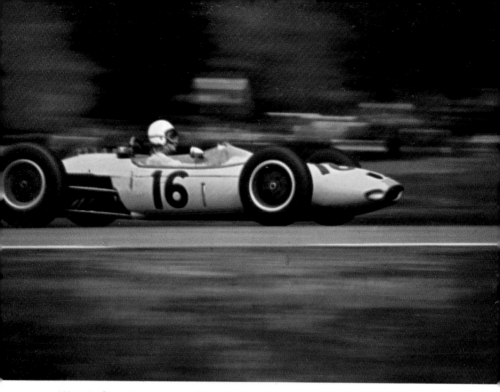

Watkins Glen, New York—a Formula 1 racing car was shot through a 135 mm lens panned with the movement. EH, ASA 400, 1/250 second at f/8.

instant of exposure. In such sports as springboard diving and pole vaulting, there is a split second of stopped motion as the athlete reaches the apex of his dive or vault. This should be the moment of exposure. You can't start to shoot at the peak of action, though—you have to anticipate it. Your own reaction time, plus the time it takes for the shutter to open after you start pushing the release, can cause you to miss the peak of action.

By using fast shutter speeds, panning accurately, and anticipating peak action, you will increase your yield of sharp action photographs.

Travel Pictures

Let's go anywhere—by car, plane, train, horseback, canoe, or foot. The function of the camera is to record the events as they appear. The camera work shouldn't get too involved because the trip should be enjoyed first and photographed second. Equipment for this documentary-type photography should be light and compact. Ideally, your 35 mm camera should have an f/2 lens, a good built-in meter, and be equipped with a compact electronic flash unit. A pushed film speed of

400 for High Speed Ektachrome Film (Daylight) is practical because it will allow you to take pictures in bright sunlight and also in the deepest shade or at dusk. Almost any camera and film will record the events that happen in bright sunlight, but lots of interesting things happen at dusk or in places where there is little light. A trail through a heavy forest, for instance, can require four or five *f*-stops more exposure than you need in direct sunlight. A flash picture would not

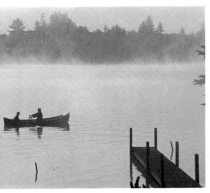

There was an early-morning fog when this picture was made from a campsite in the Adirondack Mountains. EH, ASA 400, 1/125 second at f/13.

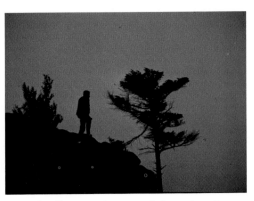

A silhouette by moonlight, taken from a mountaintop in the Adirondack Mountains of New York. EH, ASA 400, 1/30 second at f/3.5.

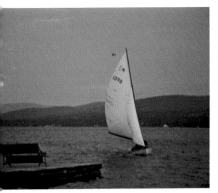

The sun had just settled below the horizon, and the lights were being turned on as this sailboat returned to port. EH, ASA 400, 1/25 second at f/3.5.

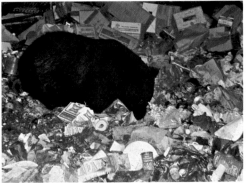

You don't want to get too close to this bear—so pushing your film speed lets you use flash from a greater-than-normal distance. EH, ASA 400, 1/30 second at f/4 with an 80 mm lens and an M5B flashbulb.

Extra film speed is helpful in places where the sun rarely shines—such as in this deep ravine at Stony Brook State Park, New York. EH, ASA 400, 1 / 60 second at f / 8.

reproduce this woodland trail as it really appeared. The foreground would be brightly lighted by the flash, but the background forest would vanish into darkness. Most twilight scenes of city skylines require the natural-light technique to record them as they actually appeared. Natural-light photographs, then, are needed whenever scenes are to be reproduced just as they appeared. Flash pictures are needed when there just isn't enough natural light for pictures, or when you want control over lighting.

This pushed High Speed EKTACHROME Film (Daylight) has advantages with flash photography as well. First of all, you can use tiny AG-type flashbulbs or flashcubes. When you push the film speed to ASA 400 you multiply your flash guide number by 1.6. If you push the film speed to 640, you double your guide number. Flash pictures can be made at greater distances when the film speed has been pushed. Let's say you want to photograph a bear while you're on vacation in the Adirondack Mountains. The bear would usually appear at night, so you would have to use flash. It is always good advice to maintain a substantial distance between you and the bear. Since most folks would prefer a close-up, a telephoto lens used in combination with the fast film and flash will bring the bear closer on the film, but no closer to you. Don't forget to increase the exposure by one *f*-stop for flash pictures outdoors at night because there are no walls or ceilings to reflect the light. The bear himself will need ½ to 1 stop of additional exposure because he is a very dark subject. Only the speed of a pushed film will satisfy all these requirements.

Underwater Pictures

The adventure of skin diving is a challenging sport that is gaining popularity very fast. If you become serious about this sport, you may want to start photographing some underwater sights. (For more information, see "Underwater Photography" in *The Fifth Here's How,* KODAK Publication No. AE-87.) Push-processing of High Speed EKTACHROME Film for underwater photography can be a great help, because there is a substantial reduction in the quantity of daylight as you go deeper underwater.

Light falls off very rapidly underwater. A wide-angle lens aimed toward the surface was used for this shot. EH, ASA 400, 1/250 second at f/6.7.

Push-Processing of KODAK High Speed EKTACHROME Films

You can increase the effective speed of High Speed EKTACHROME Film and maintain good quality by using the KODAK Special Processing Envelope, ESP-1, or push-processing the film yourself with KODAK EKTACHROME Film Chemicals, Process E-4.

KODAK Special Processing Envelope, ESP-1—Kodak will push-process your High Speed EKTACHROME Film, sizes 135 and 120 only, to 2½ times the normal ASA rating—from ASA 160 to ASA 400 for Daylight type, and from ASA 125 to ASA 320 for Tungsten. To get this service, purchase a KODAK Special Processing Envelope, ESP-1, from your photo dealer. (The purchase price for the envelope is in addition to the regular charge for KODAK EKTACHROME Film processing.) Return the exposed film in the Special Processing Envelope to your photo dealer or place the film and envelope in the appropriate KODAK Mailer and send it to the nearest Kodak Processing Laboratory. When using the KODAK Special Processing Envelope, be sure to expose the Daylight film at 400 and Tungsten at 320.

Processing the Film Yourself—By using EKTACHROME Film Chemicals, Process E-4, you can increase the speed of the Daylight film to 400 and Tungsten to 320 by multiplying the processing time in the first developer by 1.5. If you don't mind some loss in color quality, you can push the Daylight film to 640 and Tungsten to 500 by multiplying the processing time in the first developer by 1.75.

Jeannette Klute is a Supervisor of the Photographic Technology Studio in Kodak's Photographic Technology Division. Her hobby is making superb nature pictures with large-format cameras. She has had more than 200 one-"man" print shows in this country and abroad, circulated by such organizations as the Royal Photographic Society of London and the Smithsonian Institution. Her book, *Woodland Portraits*, published by Little, Brown & Co. in 1954, is a collector's item.

Editor's Note: While Miss Klute uses a large reflex camera, small single-lens reflex cameras are also well suited to flower photography. The desired shallow depth of field can be attained by using wide apertures. A 2-inch lens used at $f/2$ has about the same depth as an 8-inch lens at $f/8$ on a 4 x 5 camera. Such wide apertures also have the advantage of short exposure times.

HOW TO PHOTOGRAPH WILD FLOWERS

by Jeannette Klute

The photography of wild flowers can be very exciting, particularly if you just plunge in and make pictures that please you. Getting started is often the problem. Don't be afraid. Forget any of the formal rules of composition that you may know and start making pictures.

I want to suggest an approach to the subject which may be new to you, but which I have found useful in getting ideas for pictures. Take your camera into the woods or fields and then look through your viewer or at your ground glass and let the flower images in the camera suggest picture possibilities. When you see something exciting or interesting— perhaps a gorgeous color combination, a dramatic line that three blossoms make, or an interesting shape—you have your idea. Now get down to work and make a picture of it. Put your camera (I use an old 4 x 5 Graflex) on a tripod and keep looking at the ground glass,

not at the subject. You cannot help being affected by what you know the plant looks like, but try to be as objective as you can. Watch what it looks like in the viewer—that is your picture, not what you are thinking. Your feelings don't show in the picture unless you make them—if you feel tender, try to make the picture look that way; if you are impressed by the subject's dramatic qualities, try to make the picture dramatic; if your reaction to the subject is "How lovely," try to make a picture to which you would have the same reaction. Look over every square inch as imaged on the ground glass and try to create a picture, still keeping your original impression.

What is a picture? What are you trying to make? In making a picture you are taking a particular viewpoint of a flower and removing it completely from its environment. When it is viewed in totally different surroundings, it must continue to be a satisfying unity under the new conditions. It must be a self-contained whole. To create this picture of your idea, just keep looking and trying to make everything express that idea. It is probably even more important to guard against letting anything detract from it.

Here are a few simple practical things to do which help make a satisfying unity or picture. A simple thing helps, such as removing a distracting stick from the background. It is surprising how often something so simple isn't done merely because it is not seen by the photographer. To enhance the original impression of the flower, try darkening the background with a shadow. Perhaps a slightly higher angle of the camera will put the subject against a little darker green and make it look better. At times, moving the tripod by inches will correct the balance of a picture. Remember: You are *making* a picture, not taking it. If it is a common flower and there are more than one of them in the picture, perhaps by removing one flower you will direct the attention of the observer to the particular blossom you want him to see.

Probably when you found the subject, your camera aperture was wide open. When you get down to work, don't automatically stop it down to $f/16$ or $f/32$ without first looking carefully to see the effect. You may destroy your original carefree feeling or impression.

Sometimes you may want to repeat the color in the background. One way to do this is to move another blossom into the background but keep it out of focus. This will give you a blur of color which may help your idea. It is surprising how such a minute change can make or break a picture.

You can sometimes spend an hour or two composing your subject

and still have a spontaneous picture which looks like your first quick impression. On the other hand, you can wreck everything in two minutes; your picture can become stiff and overworked, with no freshness remaining. Occasionally you can make a good picture in two minutes, but it is usually because you have photographed the same subject before. On other occasions, a rare set of circumstances will pull everything together, and you have a picture immediately.

It may seem in what follows that I am stressing manipulation of the plant and background to make a picture; this is not the case. I always photograph the plant in its natural environment and with natural light. I do not transplant or cut a flower except when it is a common weedy type. I am also very careful not to tramp down the ground around a rare plant.

I do this for two reasons: First, our wild flowers are in danger of extinction and must be protected; and second, my aim in a picture is to make the flower look natural, and the best way to do this is to photograph it growing naturally. Most of the manipulation lies in seeing and in choosing the light, etc, although a flower may be tied out of the way with string or held back with a cord.

Mayapple

One place where many pictures fail is in the background. Since our topic here is wild flowers, we will assume a flower to be the subject. The background, however, is just as important and is the part of the picture over which the photographer has greatest control. Many changes can be made here which will add to the subject.

Let us consider what has been done and what might have been done in the two pictures of the mayapple. I have included a pair of pictures to show the effect of lens aperture on the background. The pair was taken, one after the other, without moving the camera and with only the aperture and shutter speed changed. Picture A was made at $f/8$ and Picture B at $f/45$.

Out-of-focus backgrounds offer many possibilities. In the first place, they make the plant stand out clearly. The trees in this picture have become long, vertical dark lines which, in context, suggest a woodland. The blue sky has become a large blur of blue which adds a note of color relief to the otherwise all-green picture. The all-green effect was one that I had found interesting. Objects can be added for their color alone. The area of green to the left of the picture was introduced deliberately by adding the leaf shown in the $f/45$ picture. I wanted this

large area of green to balance the green in the upper right-hand part of the picture. Since the shadow on the trees in the background is out of focus just in back of the blossom, it gives a dark-green surrounding for the white flower. If I had wanted it for my picture, I could have introduced any color—even a piece of red paper if I had needed a spot of red, for instance. An out-of-focus background has to be carefully handled. Of course you can put anything in, or make the background out of focus to any degree, but it must not detract from the theme of your picture. An object which arouses too much curiosity will draw attention to itself. In general this will not happen if the background is completely out of focus or if it is a repetition of the main object. It is interesting to notice that the large aperture also takes out the blade of grass between the flower and the camera.

Returning to the picture, I strongly recommend low tripods for flower photography. However, for this picture I needed such a low angle that I dug a small hole in the ground to get the camera low enough. Other times I have used a flat board on the ground, propped up with wooden wedges.

Because the light coming through the leaves was so green, I used a foil reflector to throw white light on the blossom.

Mayapple A Podophyllum peltata
4 x 5 KODAK EKTACHROME Film
6115, Daylight Type (Process E-3),
8½'' EKTAR Lens,
f/8, 1/25 sec, 2:30 p.m.

Mayapple B
Same except f/45, 4 sec.

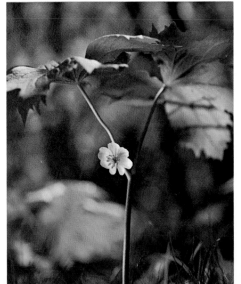
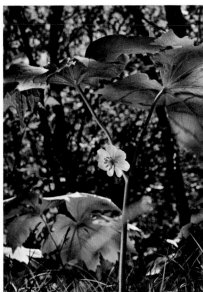

Jewel Weed

For many reasons one of my favorite times to work with flowers is just after a rain. In this case it was the rain that helped make the picture. I had tried many times to photograph the jewel weed and had failed, but it always seemed to me that it had picture possibilities. The plant is fairly large, growing nearly three feet high with many small blossoms about one inch in size spread at random all over the plant. A long shot was poor because it was difficult to see the blossoms and the plant looked like a jumble. When I came in close, the little blossom seemed insignificant. The blossoms did not grow in lovely groups of three or four, as do those of the trillium or jack-in-the-pulpit, which allow the photographer to have an easy composition. So the problem here was to find some way to show the beauty of this plant. In this case the raindrops clinging to the blossom and the leaves formed a pattern in their own right which added interest to the picture. The brightness of the raindrops is caused by the reflection in them of the overcast sky above the horizon in the background. The dull light showed the color of the small blooms and allowed the small pattern of darker colored dots on the flower to be seen. Bright sunlight with strong shadows would have cut up the flower too much.

The background at some distance and in dull light provided a dark backdrop with a slight variation in color, which in this case set off the green leaves and the orange blossoms, and added a subtlety of feeling. A black card would not have given the same effect; I feel it would have been too dark and somber for the picture I was making. Such a card can be too plain and sometimes lacks realism.

The leaves in the back were made slightly out of focus to soften their outline. When they were in focus, they detracted from the plant; and if they had been taken out, the base would have seemed too bare.

Wind is a serious problem for the photographer when working with a fragile flower such as this. Try to work just after a rain when it is often quiet. On windy days try the deep woods, or try plants that grow close to the ground. Use windbreaks: nylon cloth clipped to poles, large white cards, heavy foil (which may be folded for ease in carrying), or a carrying case or knapsack. Any of these placed close to the flower will give added wind protection. Winds are often calm early in the morning.

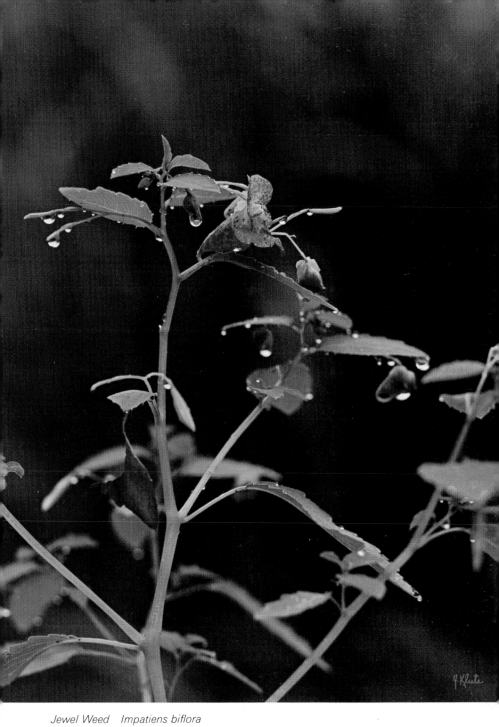

Jewel Weed Impatiens biflora

4 x 5 EKTACHROME Film, 10'' EKTAR Lens, f / 16, 1 / 10 sec, 10:40 a.m. **27**

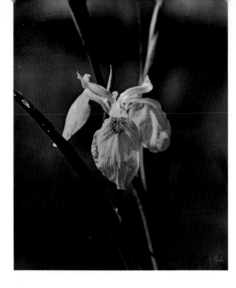

Water Flag
Iris pseudocorus
4 x 5 EKTACHROME Film,
10" EKTAR Lens,
f / 8, 1 / 100 sec, 8:45 a.m.

Water Flag or Iris Pseudocorus

When you have a beautiful large blossom, you can often make a dramatic picture by coming in close to the subject. The problem here was to show the form of the flower and to make it glow the way it did when the sun was shining. Iris are wonderful to work with because there are so many ways to photograph them. This plant could be photographed in soft misty light with a green background, giving it an ethereal quality. Or, you could show two or three blossoms, making a lively picture with two or three bright yellow spots forming the composition. The possibilities are limitless. You could spend an entire day just trying to see how many completely different pictures could be made from a single plant.

Now let us get down to making a dramatic, glowing picture of this iris. The flowers grow in large clumps in wet places. The plant is two or three feet high and the blossoms are three to four inches across. I chose a clump growing at the edge of a pond so I could use the water as a background. Water is one of the best backgrounds for this type of picture. Try looking in your ground glass at water. The range of colors is tremendous. For this picture I wanted a rich dark blue to set off the yellow. I wanted the maximum color contrast possible for the maximum punch.

This picture, too, was taken after a rain as you can see by the few raindrops on the left-hand leaf. The rain seemed to have made the blossoms slightly translucent. The sun came out in full force, lighting the flower from above and slightly from behind it. The petals seemed to be full of sunshine. The light coming through the petals and grazing the surface of the plant sepal provided the glow that I wanted.

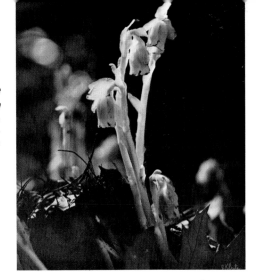

Indian Pipe
Monotropa uniflora
4 x 5 EKTACHROME Film,
8½" EKTAR Lens,
f/8-11, ½ sec, 3:30 p.m.

Indian Pipes

It is a standard rule in pictures that contrast in the subject should not exceed the density range of the film. This means having good detail in the highlights and in the shadows. This holds true in most cases; however, this is a rule that can be broken to produce a desired effect. In the case of these Indian pipes, I was trying to achieve a feeling of eeriness and mystery. The underexposed black was intentional, and I was able to get the effect by waiting for the light to shine on the plant from the back, giving more contrast than the film could handle. Backlighting is a very useful tool for the photographer, but the problem of exposure is difficult. I always bracket the exposure, but in the case of backlighting I may make as many as five to seven exposures because it is impossible to tell without seeing the result just which exposure will be right. The time of day was midafternoon, and the sun coming through the openings in the trees acted like a spotlight on the plant. The light came through the whitish leaves and some of them are slightly overexposed. The light on the tree trunk in the background was so dim that it did not register. This gave the effect I was after. It was necessary to use a white card to reflect light onto the plant to get some of the mid-tones. Only a little reflected light was used, because I needed to keep the foreground dark to avoid the distraction of the pine needles and dead leaves at the bottom of the picture. The almost totally out-of-focus fragment of plant in the background makes it hard to see, and gives a merest suggestion of the other plants. The fact that it is hard to see tends to make it mysterious. Of course, this can be easily overdone.

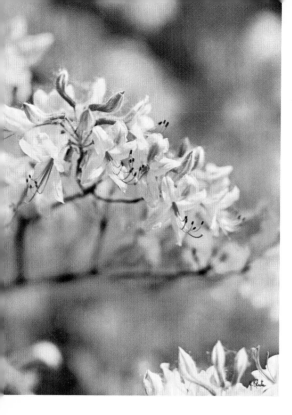

Azalea or Pinkster Flower

This azalea was a shrub three to four feet high, with a cluster of blossoms about a foot from the ground. The pale pink and general brightness of the images on the ground glass first caught my attention. When I pointed the camera at the bush, everything was out of focus and I had the effect I wanted, but the picture had no form. To get this form, I found a row of blossoms which gave me a strong line and yet were far enough from the others to give me the background I wanted. To increase the flow of line toward the bottom of the picture, I tied one of the branches up to the other so that its blossom appeared in the lower part of the picture. The conflict here was how much to have in focus and how much to have out of focus.

One of the biggest problems was to find a camera angle in which the branches were not too sharp. I wanted to play down the blackness of the branches. Remember, an out-of-focus object appears much less dark.

Focus is such an important tool that you must be sure to make it work for you.

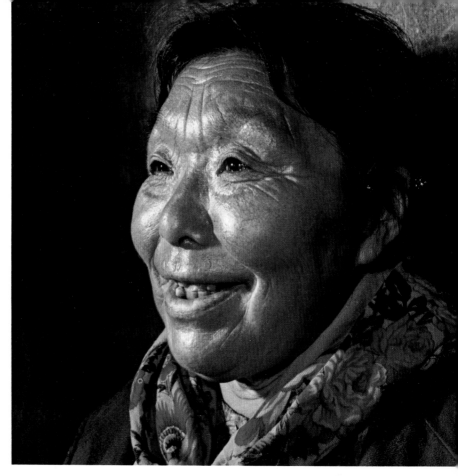

Two portable electronic flash units provided this pleasing lighting. The main (stronger) light was at the side in line with the woman's face. The fill-in light at the camera illuminated the shadows. I covered about half the flash reflector of the on-camera light with my fingers to make it weaker than the main light.

The formula for placing the main light, or side light, is in the preceding sentence. It's so vital that I'd like to restate it like this. *The main (stronger) light should illuminate the frontal planes of the subject's face, no matter which direction the subject is facing.* In other words, the subject's nose should aim directly toward the main light.

Let's refine this a bit. The light should be above the subject's head, but not so high that the subject's eyes won't pick up catchlight reflections from it. It goes without saying that the subject does *not* face the camera squarely in "mug-shot" fashion. This makes poor pictures with any kind of lighting (unless the subject is very close to the camera).

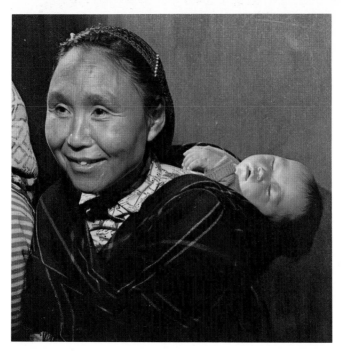

Madonna and child, Eskimo style. Notice the delicate sidelighting on the child's face. This effect would have been ruined by using only a single flash at the camera position.

It Takes Teamwork

You need a slave to hold the slave! A wife, husband, or friend makes the best "second-light holder" we know of—and is far more flexible than a tripod. After the first few pictures, your helper will know the job well enough to require only a few instructions.

Exposure Determination

Just as in studio lighting, exposure for this portable, two-light system is based on the stronger light—your off-camera slave unit. Divide the guide number by the *slave*-to-subject distance. The fill-in light at the camera doesn't even enter into the exposure calculation. *If*, however, you use the slave unit as a top, back, or background light, determine exposure by the *camera* light-to-subject distance. You'll find the direct-reading "Do-It-Yourself Flash Stickers" in the *KODAK Master Photoguide* handy. Apply one to each light.

P.S. After proofreading this article, an ex-friend of mine told me: "Yes, but all this flash stuff doesn't apply to me because I use a real fast film with a fast-lens camera." How do you ever get through to a person like that?

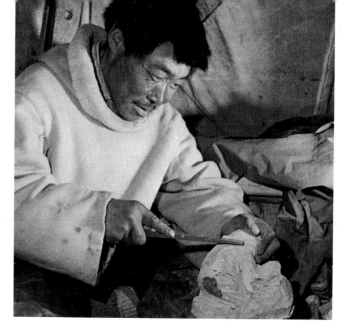

A popular Eskimo art form is carving soft soapstone. These imaginative and individualistic artists never make two designs the same. Again, notice how the main light is coming from the side the Eskimo is facing.

This woman defleshing a seal hide with an Eskimo knife called an "ulu" was photographed inside a tent. I used the two identical electronic flash units I recommend as standard equipment for top-notch travel pictures. Always keep the main light to one side, and make it brighter than the on-camera light by positioning it closer to the subject. If both lights have to be the same distance from the subject for some reason, cover part of the on-camera light reflector with your fingers and base exposure on the off-camera light.

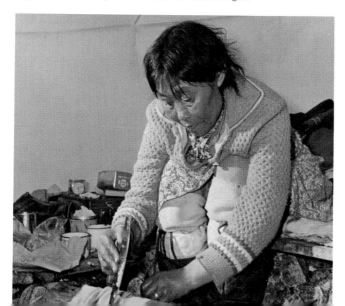

Jack M. Streb is Director of Consumer Markets Product Planning for still equipment. Formerly, he was Director of Kodak's Photo Information department which receives thousands of letters each week from people requesting photographic information. Jack has presented his slide and movie programs to audiences all over the United States and Canada. As former Director of Consumer Markets Publications, he supervised the publishing of numerous KODAK Photo Books and KODAK Customer Service Pamphlets.

BEHIND THE COLORAMA *by Jack M. Streb*

High over the vast interior of New York City's Grand Central Terminal glows the largest transparency in the world. It's called the "Kodak Colorama." The giant 18 by 60-foot transparency is illuminated from behind by more than a mile of cold-cathode tubes, and has a picture area equivalent to more than 10,300 35 mm negatives.

A new picture has been displayed every three to five weeks since May 15, 1950. The story behind the planning and taking of these huge pictures offers a fascinating glimpse of professional photographers at work—and a short course in just about every photographic technique you can imagine.

Most of the pictures are taken by the photographers of Kodak's Photo Illustrations Division—a small group of highly skilled and

awesomely resourceful professional lensmen. The men in "PID," as the group is called around the office, are responsible for most of the pictures Kodak uses in magazine ads, dealer displays, and the thousands of pieces of literature Kodak publishes.

Every photographic problem you're ever likely to encounter turns up in spades when you're trying to shoot a Colorama. This results partly from the massive scale of the project. Obviously, conventional-size negatives won't produce sharp enlargements 60 feet long. So a camera, adapted to use 8 by 20-inch sheets of KODAK EKTACOLOR Professional Film 6101, Type S, was created to shoot Colorama negatives. It weighs as much as a loaded three-suiter, has the bulk of a small doghouse, and requires the patience of a Matthew Brady to use it successfully. The shortest lens that will cover its oversize negative has a focal length of 14 inches, or over 350 mm. Depth-of-field problems are often severe, to put it mildly. Scenes that might be photographed with relative ease in smaller, conventional equipment become more difficult with this cumbersome box.

Then there are the usual problems of weather, lighting, subject control, and model availability that affect every photographer. Add to that the problems often encountered in transporting and using this equipment all over the world, in strange countries and climates. A few examples of the difficulties routinely met—and overcome—will show what we mean.

A Kodak photographer on assignment in South Africa focuses a 48-inch lens mounted on the oversize Colorama camera to shoot some distant wildlife.

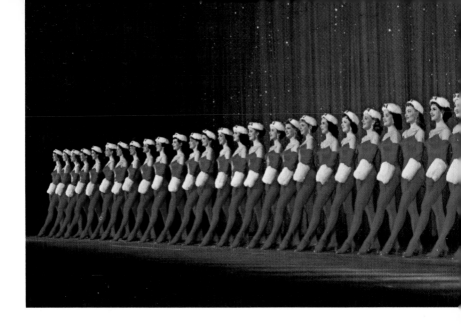

Shooting the Rockettes

Your assignment: Go to the Radio City Music Hall in Manhattan and shoot a Colorama of the internationally famous precision dance team known as the "Rockettes." Sound simple? Let's see how PID photographer Bob Phillips did the job.

Weeks of careful planning came before the final hectic day when the picture was made. It was obviously impractical to shoot the carefully planned scene during an actual show, so it had to be done early in the morning. When the theater closed at midnight following the last show, the 36 Rockettes who would be in the picture slept in their Radio City dormitory so they would be on hand for an early-morning set call.

Then a careful work plan as closely scheduled as a Rockette dance routine went into action. During the night, three tons of equipment were moved into Radio City, including 88 professional electronic-flash condenser units—the greatest concentration of "strobe" lighting ever assembled for a single picture at that time. Each of the dozens of flash heads had to be carefully positioned, wired to its power supply, and test-fired. Every piece of equipment down to the last connecting cord and piece of tape had to be in the right place at the right time.

While electricians rigged the lighting units, stagehands shifted 55 by 90-foot "drops" into place. A blue-nylon reflector curtain was rigged to bounce the lights. Window mannequins trucked in from 5th Avenue

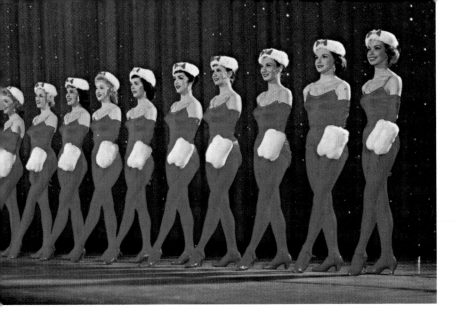

stores were dressed in Rockette costumes and placed on the stage for test exposures. Brawny stagehands locked arms and "stood in" for the Rockettes for some of the tests. The actual dancers would occupy a 72-foot length of stage. By adjusting swings and tilts, Bob was able to get everything in focus with the camera's 16-inch lens set at $f/20$.

By 4:30 in the morning, the test shots were completed and rushed to a lab for processing to make sure lighting, model positioning, and exposure were satisfactory.

When the girls appeared the next morning, they had to change their usual order. Normally the taller girls stand in the center of the stage to give the audience the appearance of a straight, even line. To produce the desired perspective in the picture, though, the tallest girls had to be placed farthest from the camera.

With girls, lights, camera, and background all in order, Bob was ready to shoot. Then he noticed a distracting light bouncing from the orchestra pit. He tore up a sheet of black paper and suspended a piece of it from tape stuck *inside* the camera bellows. According to the ground-glass image, the problem was solved. But would it change the exposure, or any of the dozens of other variables? Thousands of dollars and dozens of people were involved in the success of this button-push. Bob tripped the shutter.

The result was one of the most spectacular of the Colorama pictures. It was used not only in Grand Central Station but also on the front and back covers of a record album featuring Radio City talent.

Hong Kong Harbor

On the other side of the world from New York City, Kodak photographer Lee Howick met a different set of problems in trying to photograph Hong Kong Harbor at dusk. After much searching, Lee found the right spot for his camera—at the end of a steep, rugged, rocky road that led to a cliff high over Victoria.

It was so windy on the cliff that Lee had to build a makeshift windscreen out of focusing cloths to prevent his big camera from moving during the time exposure that would be necessary for the dusk shot.

One of the best times to take "night" pictures is after the sun has

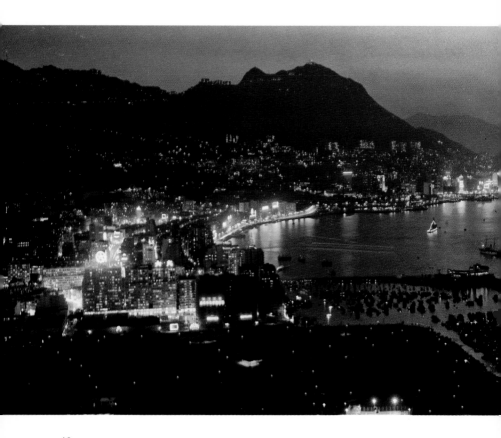

gone down, but before the sky has turned completely black. Lee settled down early in the evening and waited for just the right moment.

When the light level was about the same in the sky and in the lights of the city, it was too dark to even see the numbers on the exposure meter. Lee "guesstimated" the exposure at 60 seconds, with the 14-inch lens set at $f/16$. A few streaks of lights from moving boats show on the water, but the big boats at anchor are tack-sharp. The picture drew admiration in Grand Central Station and was used as the center spread in a Kodak Annual Report.

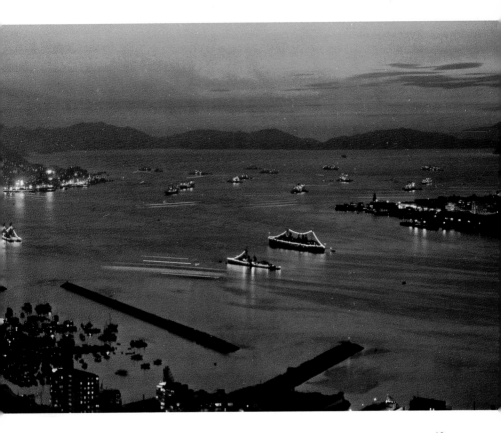

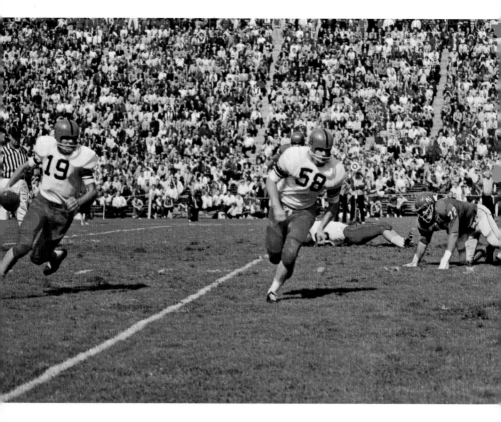

Action in 8 x 20

For several reasons, an 8 by 20-inch view camera mounted firmly on a heavy tripod isn't the ideal tool for photographing action subjects: It has no viewfinder. There's no chance to change focus during the action. It can't be moved quickly to follow the action. With its long lens, depth of field is pitifully shallow. And, to top everything, the normal top shutter speed of the Colorama camera is only 1/150 second.

Kodak photographers Wes Wooden and Pete Culross had some problems to solve when they were assigned to shoot a college football game for Colorama use.

They tried to capture a football game at Pittsburgh one Saturday. No luck. They tried Penn State another Saturday. It poured through the whole game. Even when the weather was good, the 1/150-second shutter speed wasn't fast enough to stop the action.

After considerable research, Wooden and Culross located a special

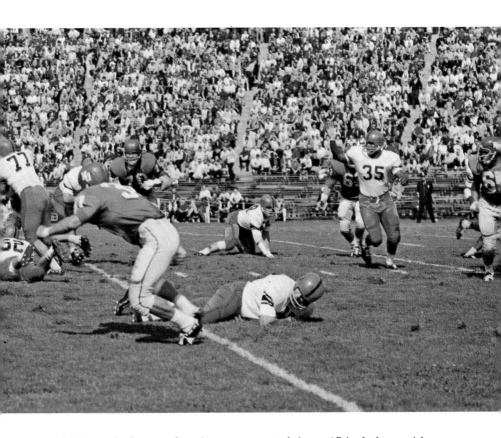

high-speed shutter—but it was mounted in a 17-inch lens with a maximum aperture of $f/17$. They determined that they could shoot at 1/250 second with the lens wide open and get a usable image by "pushing" the film during processing, as long as the sun was shining brightly.

Another Saturday found our photographers at the Syracuse-Kansas game in Syracuse, New York. A heavy cloud cover melted away just before kickoff. The pair set up their ungainly camera only a few feet from the sidelines, then sent helpers onto the field to determine what area would be in the picture and how much would be in sharp focus. Then they sat and waited for the action to come to them. It came, all right—players charging out of bounds crashed close to the camera. Once they actually hit it. The big tripod teetered—then righted itself. They kept on shooting, 19 sheets of film in all. The best negative was chosen, and the first outdoor action Colorama went up in Grand Central.

Alps Adventure

As PID photographers circle the globe for pictures, they often have unexpected adventures. Kodak photographer Neil Montanus chartered the services of a Swiss pilot to help him find a good spot in the Alps for a Colorama assignment. As they flew, they saw on the snow below them a crossed-skis distress signal. They landed, to find that a man had fallen into an icy crevasse hundreds of feet deep. By a lucky chance, his fall had been stopped by a snow shelf only 30 feet down. The pilot radioed for help, then took off to lead a rescue party back to the scene. The accident victim was rescued, everyone involved joined in a party—and no pictures were taken that day. On the following day, Neil tried again and produced the colorful picture shown here.

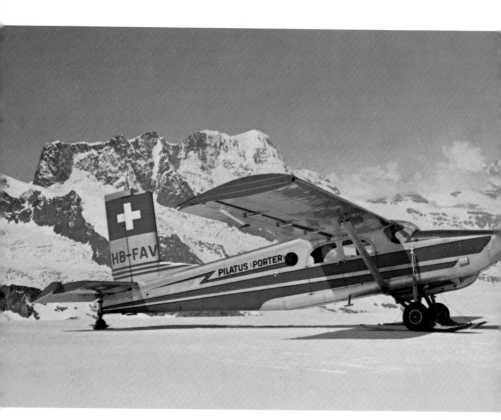

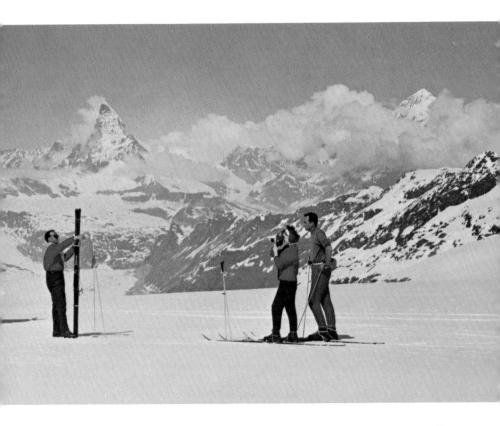

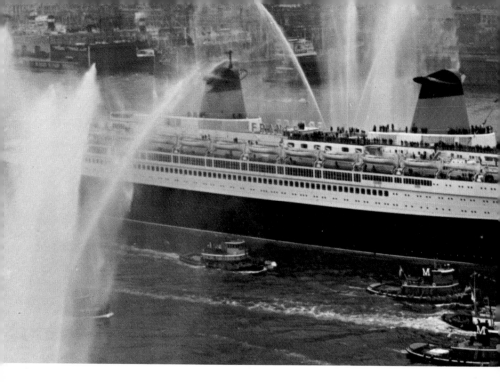

From the Air

Several Kodak Coloramas have been shot from airplanes or helicopters by PID aerial photo expert Ralph Amdursky. For his aerial Coloramas, Ralph shoots with a modified aerial mapping camera with a 24-inch, $f/5.6$ lens. A roll of film 9½ inches wide and 75 feet long is driven through the camera electrically. Each long roll of KODAK EKTACOLOR Professional Film can produce 40 Colorama-size negatives.

The camera is focused on infinity. When he wants to photograph closer subjects, Ralph inserts shims between the lens and the camera body. The closer the subject, the more shims he uses to increase the lens-to-film distance. Once the camera is airborne, focus is fixed for a specific distance and can't be changed.

One of Ralph's Colorama assignments was to photograph the luxury liner *France* entering New York harbor on her maiden voyage. This was a "news"-type shot, with absolutely no chance to control the subject or wait for good weather.

A gloomy winter day awaited the arrival of the *France*. Ralph and his equipment hovered overhead in a chartered helicopter. He had learned

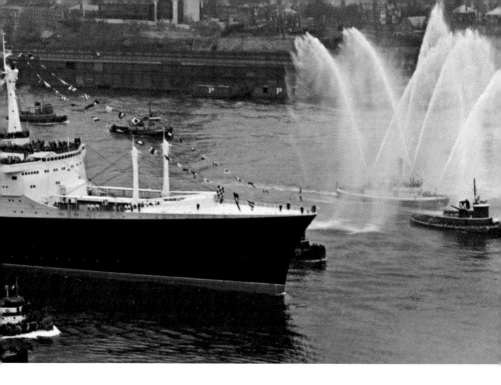

the length of the ship so he'd know how many shims to use behind the lens to produce the right distance and field size. As the ship neared port, everything seemed in order.

Then Ralph noticed his exposure counter. It said the film in the magazine was exhausted—and he hadn't yet made a single picture. A quick check revealed that a short circuit in the electric-drive unit had run the entire roll of unexposed film through the camera. And there was no more film on board the helicopter.

With the *France* coming over the horizon, he quickly had the pilot fly back to LaGuardia Airport. He grabbed a fresh roll of film and performed the ticklish job of reloading the yard-long camera in flight. Hovering at the right distance from the ship for his prefocused lens, Ralph got a beautiful shot of the *France* coming into the harbor, accompanied by tugs and fireboats shooting tons of water skyward in welcome. The negative was rushed through processing, and a 60-foot transparency was made in Rochester, assembled, shipped to New York City, and hung in Grand Central before the *France* left New York. From shooting to display took only 96 hours.

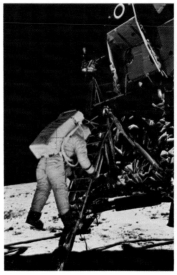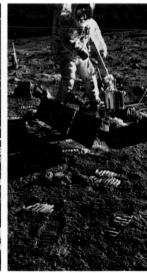

From the Moon

This Colorama of man's first steps on the moon was rushed through to completion so that it could be on display while the Apollo 11 astronauts were in New York City for a ticker-tape parade.

Apollo 11 commander Neil A. Armstrong took these pictures on KODAK EKTACHROME Professional Film, Daylight Type (Process E-3), using a Hasselblad Camera fitted with a special lens. The camera was left on the moon to lighten the load for lift-off, and only the film returned to earth with the astronauts. After the film was held in quarantine to make sure that it had brought no "moon germs" to earth, it was released and rushed to the processing lab at the Manned Spacecraft Center in Houston, Texas. The processed EKTACHROME Film was flown to the Kodak lab in Rochester, New York, on Thursday. Double crews worked around the clock to create the giant Colorama in just 48 hours —a process that normally takes three weeks! By Sunday, the Colorama had been trucked to New York City and was installed. It was lighted

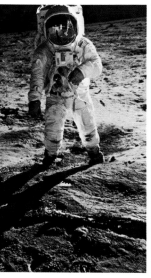
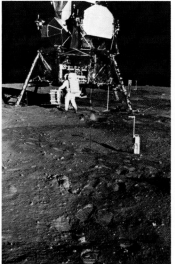
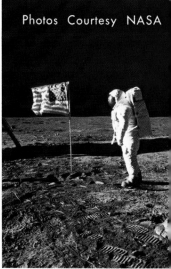

during a special ceremony on Monday, when Dr. Louis K. Eilers, president of Eastman Kodak Company, presented it to the people of New York "as a tribute to the astronauts of Apollo 11—and to the entire National Aeronautics and Space Administration team."

From left to right, the dramatic pictures show astronaut Edwin E. "Buzz" Aldrin, Jr., descending from the lunar excursion module against the stark surface of the moon and the cold darkness of space. Next he sets up the seismometer, which was left behind to record moonquakes and the impact of meteorites. A space portrait of Aldrin shows the LEM with photographer Armstrong reflected in Aldrin's faceplate. Then we see Aldrin unloading equipment from the LEM in the background, while in the foreground a special stereo camera designed and built by Kodak to record the texture of the moon's surface awaits its turn at picture-taking. The final picture shows Aldrin beside the American flag unfurled on the lunar surface. The crosses on each picture enable geologists to make precise photogrammetric measurements of the objects within the picture.

From the Sea

Taking pictures underwater poses some very special considerations that photographers on land don't encounter. Neil Montanus spent two years planning and testing before he could photograph this underwater Colorama.

First he had to find a way to keep the camera dry. The 8 x 20-inch view camera enclosed in a watertight housing would have been most unwieldy, so Neil had to find a substitute camera—a camera with a smaller body but one that could accept a large negative size. He adapted a K-17 Aerial Camera, which is about half the size of the Colorama camera and produces a 9 x 9-inch negative. With KODAK EKTACOLOR Professional Film, Type S, in aerial rolls, Neil could take 125 pictures during one dive. The camera was enclosed in a Plexiglas watertight housing which was fitted with a wire viewfinder shaped in the Colorama format.

Although the overall negative size was 9 x 9 inches, the part of the negative used for the Colorama was $2\frac{5}{8}$ x 9 inches. This was not only the first underwater Colorama, but also the first time a Colorama had been enlarged from such a small negative.

Underwater photographers usually take along some lighting equipment, because the intensity of sunlight filtering through the water gets weaker as they go deeper. Sealed-beam movie lights were used to bounce light into the shadow areas and to put some red light back into the scene. (Water filters out the red light in sunlight, and underwater pictures often look extremely blue.) The lights had to be carefully insulated to avoid any possibility of electric shock, because salt water is a

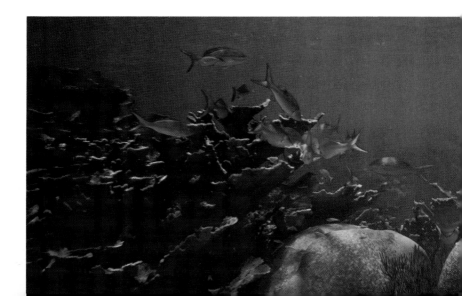

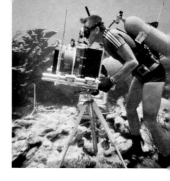

The K-17 Aerial Camera is enclosed in a Plexiglas watertight housing which has a wire viewfinder shaped in the Colorama format.

very good conductor of electricity. A generator which supplied power to the lights floated in a dinghy over the "underwater studio."

Neil and his crew of divers and models spent months testing the camera and lighting equipment in local swimming pools. Then they made location tests in Florida and the Virgin Islands. The first test pictures were disappointing because the water wasn't clear. Finally, they were ready for the final shooting in the Underwater National Park at Buck Island off St. Croix in the Virgin Islands.

Five people put on their scuba gear and took the equipment to the bottom of the sea. One of the crew acted as a lookout for the sharks and barracuda that often took a keen interest in the underwater studio. Neil and his helper set up the camera and sturdy tripod on the sandy bottom. The two models were in place, but where were all the fish? To attract the fish, the crew tied frozen chicken legs behind the pieces of coral. Even with the chicken to lure them into the camera range, it was several days before the fish trusted this strange setup enough to stay in the area for any length of time. After two years' work, Neil finally got his underwater Colorama.

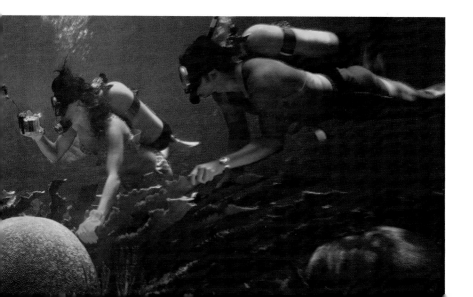

HOW COLORAMAS ARE MADE

By the end of 1971, more than 360 brilliantly colorful panoramic views from all over the world had gone up over the East Balcony of Grand Central Terminal. Every one has a fascinating story behind it. We wish we had the space to tell them all. There *is* one more interesting story to tell. It concerns what happens to a Colorama negative after it's been shot.

Although most Coloramas are shot on a sheet of film measuring 8 by 20 inches, the Colorama is actually enlarged from an area of the negative measuring only 4⅞ by 16¼ inches. A giant enlarger projects the negative onto KODAK EKTACOLOR Print Film 4109 (ESTAR Thick Base). Since the whole Colorama is too big to make in one piece, it's made up of 40 vertical strips, each 18 feet high and 19 inches wide. Each strip is enlarged from a half-inch-wide section of the negative. The 40 strips of film are carefully registered, spliced together with transparent tape, and rolled onto an 18-foot-long spool. Film, spool, and a special packing box—a half-ton load—are then shipped from Rochester to New York City.

Four specialists in Grand Central Terminal remove the old transparency and hoist the new one on its spool to a platform on the smallest "railway car" in Grand Central. The bottom end of the spool rides a small truck down a tiny railway, unwinding the transparency as it goes. The Colorama transparency itself is held tightly by springs attached to the huge steel supporting frame. The change is made in the small hours of the morning, and the lights go on behind the newly hung transparency in time for the 8 a.m. Monday opening. The entire cycle is presently repeated at about five-week intervals.

The next time you see the Kodak Colorama in New York City—or one of the miniature versions used as displays by photo dealers all over the world—take another look. We hope you'll be reminded of the story behind the Colorama.

Every three to five weeks since May, 1950, a new 18 by 60-foot Colorama transparency has been hung in New York's Grand Central Terminal.

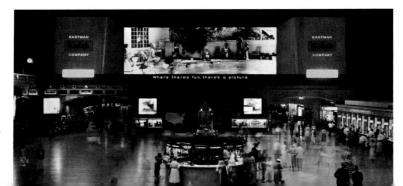

Paul D. Yarrows, FPSA, FRPS, Hon. FPSSA, is a Program Specialist in Kodak's Consumer Markets Division. For several years, Paul has ranked among the top amateur photographers in the world, with more than 3,000 acceptances in international exhibitions. Paul is the first person to hold three 5-star ratings in the Photographic Society of America in color, black-and-white, and nature photography. His imaginative photographic lectures have been enjoyed throughout the United States and Canada.

COLOR-SLIDE MANIPULATION *by Paul D. Yarrows*

For years, advanced amateurs have used various techniques to present their slides in a different manner from the casual snapshooter. Whether for camera-club competitions, international exhibitions, or personal use, they have found that some of the greatest rewards in color-slide making lie in using their creative talents to communicate their ideas.

This article describes some of the techniques I've found useful. It's important to mention at this time that whatever gadgetry is used, it is the result that counts. You are free to use your imagination to interpret the world as you see it. The techniques in this article may help you create a mood or achieve a special effect which will allow you to express yourself photographically.

Note: Some of these techniques for slide manipulation require unusual materials. A list of sources of such materials appears on page 64.

The original transparency of the silhouetted tree was intentionally overexposed.

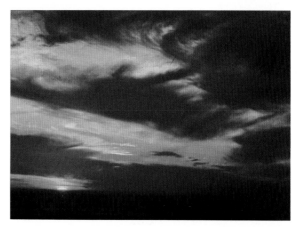

A normally exposed sunset provided the background.

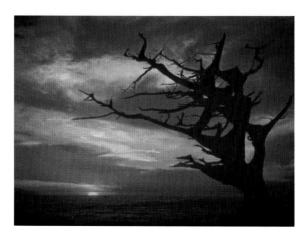

A montage was created by binding both transparencies in a single slide mount.

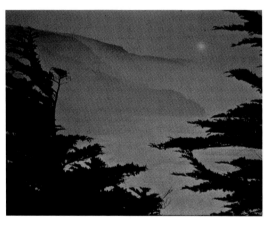

Here's another montage, made by binding the overexposed slide of the sun with a misty scenic slide.

COLOR-SLIDE MONTAGES

Occasionally you may find in your collection of slides several that are overexposed. Save them. They can be used in a "sandwich" with other slides to produce some pleasing results. The expert may even overexpose just for this purpose.

Montage Technique

First, remove the two transparencies from their cardboard mounts. Next, place the two in contact with each other and position them in a mask. Then bind the transparencies and mask between glass.

A bright sun peeking through a hazy sky, or a colorful sunset is easy to sandwich. Other subjects to keep in mind for montages are tree bark, textured cloth, and peeling paint. Remember, the final density of the combined slides should be the same as one normally exposed slide. Bracket your exposures so you have a choice of densities to pick from.

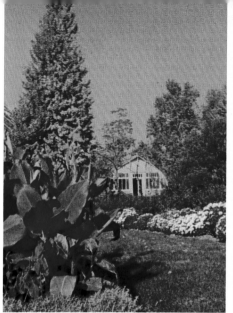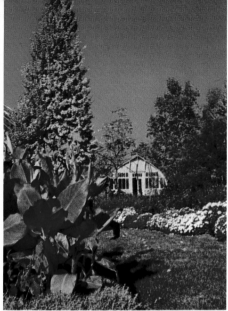

KODAK EKTACHROME Infrared Film can produce strikingly unusual pictures. Shot without a filter, it has an overall reddish or magenta cast (left). A yellow No. 12 filter is recommended for use with EKTACHROME Infrared Film. You can also get acceptable results with a yellow No. 8 or orange No. 15 filter.

KODAK EKTACHROME Infrared Film, Size 135

For way-out photo fans, there's a "way-out" film. KODAK EKTACHROME Infrared Film will launch you into a new world of color photography. An exposure index usually applied to color films for ground photography has not been assigned to this product. As a starting point, try a basic exposure of 1/125 second at $f/16$ in bright sunlight through a No. 12 filter. This exposure should be bracketed by one half stop and one full stop to insure getting a slide with the correct exposure. Keep records of what exposure and filter you use so that you can repeat the effects when you want to. Try a variety of filters used for black-and-white photography to obtain different "offbeat" colors. Keep the film refrigerated until several hours before use.

Processing—Your photo dealer can send this film to Kodak or another laboratory, or you can mail it directly with the appropriate prepaid processing mailer.

To process the film yourself, use KODAK EKTACHROME Film Chemicals, Process E-4. Total darkness is a must. No safelights of any kind can be used during processing.

Multiple exposures of illuminated signs on a single frame of film can produce brilliantly colorful results.

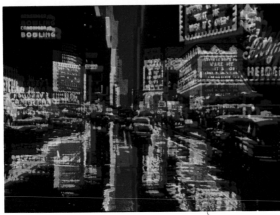

This triple exposure was made through green, red, and blue filters. The camera was moved slightly between exposures; each picture was made through one of the three color filters.

If you send your film to a custom-processing laboratory or another commercial processor, be sure to indicate the type of film you are sending. You might attach a conspicuous note reminding the processor of the no-light requirement.

MULTIPLE EXPOSURES

A multiple exposure simply means taking two or more pictures on the same frame of film. This technique involves cocking the shutter of the camera without advancing the film. Check the instruction manual of your camera to see how to do it. When starting out, you'll find that night scenes give the best results. Subjects can be separate or merged together, and shot from various angles.

Try a triple exposure—the first through a red filter, the second through a blue filter, and the third through a green filter, moving the camera ever so slightly between exposures.

Original transparency,
made on KODAK
EKTACHROME-X Film.

High-contrast negative
made by contact-printing
original transparency
on KODAK Professional
Line Copy Film 6573.

DERIVATIONS

One kind of derivation is the result of sandwiching a black-and-white negative made from a color slide with the slide itself, slightly out of register, to form a characteristic outline, or bas-relief effect.

For a dramatic effect, you can make the black-and-white negative on KODAK Professional Line Copy Film 6573.* If you use the 4 x 5-inch sheet film, you can make several negatives at the same time. Remove the slide from the cardboard mount and place it on the Professional Line Copy Film, emulsion to emulsion. Use a printing frame or place a large piece of glass over the slide and the Professional Line Copy Film so that they will be in close contact. With the light from a 25-watt bulb,

*You can also use KODALITH Ortho Film 2556, Type 3 (ESTAR Thick Base), and develop it in KODALITH Developer. KODALITH Film is sold through suppliers of Kodak graphic arts materials (listed under "Graphic Arts Materials" in the yellow pages of your telephone directory).

make an exposure. Try one or two seconds from a distance of about three feet. Keep a record of your exposures. It may be necessary to make several to arrive at the exposure that suits your purpose best. Once you know the basic exposure, you're set for future attempts. Process the film in KODAK HIGH-LINE Developer.

Wash, fix, and dry the film as suggested on the instruction sheet that comes with the developer. Since the exact degree to which a negative and slide are off register is important, assemble and tape the negative and slide film over a light box or white card. Place them in a KODAK Mask for Glass Slides; then bind them between glass.

To make this cross-eyed owl, I cut out the eyes from a color print of an owl. I glued the black part of the eyes onto yellow paper and then put them into place from the back of the print. After copying the picture onto color-slide film, I made a Diazochrome derivation. Making derivations with Diazochrome film is explained on the next page.

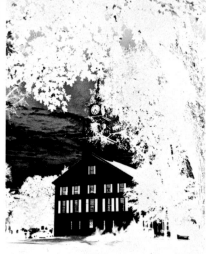

Original transparency.

High-contrast negative made on KODAK Professional Line Copy Film 6573.

DIAZOCHROME FILM

If you're not satisfied with the original color, change it! Here's how. Make a high-contrast copy negative from a color slide by placing the slide in contact with KODAK Professional Line Copy Film 6573, as previously suggested. Then place the high-contrast negative in contact, emulsion to emulsion, with a colored Diazochrome film of your choice. You can handle the Diazochrome film in normal room light. This film is available in large sheets and can be cut into 2-inch squares for use with 35 mm slides. At the top of each sheet is a notch. When the notch is at the top right side, the emulsion is toward you. (The emulsion side also feels sticky when you touch it with a moist finger.)

Hinge two pieces of slide cover glass with tape at one end to form a miniature printing frame. The Diazochrome film comes interleaved with sheets of paper that are silver on one side. Cut a 2-inch-square piece of this silver paper and place it between the glass. Then place the high-contrast negative and Diazochrome film in the glass printing frame, with the Diazochrome film between the negative and silver backing paper. Tape the two pieces of cover glass together. Expose the film by placing it in a 500-watt slide projector with the negative toward the light source for 1 minute. (Again, keep records on your exposure and development times for future use.) The dark areas of the negative are reproduced as colored areas on the Diazochrome film, and the clear areas of the negative should remain clear with no color.

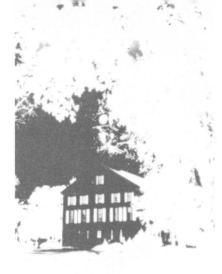

Red Diazochrome made by contact-printing a piece of Diazochrome film with the high-contrast negative.

This derivation was produced by binding the Diazochrome with the original transparency.

The water lily is another derivation made with the Diazochrome film process. Blue Diazochrome film was used in this case.

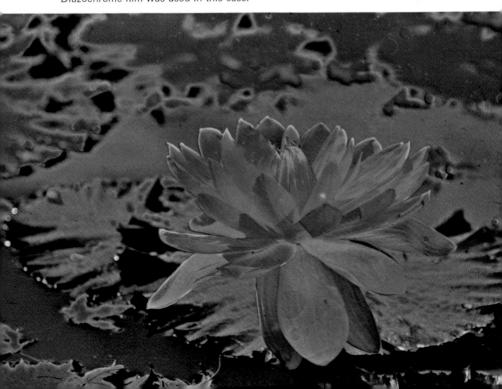

You can use any large jar for developing Diazochrome film. The "developing tank" in this picture is made from a large salad-dressing jar. Remove the cardboard insert from the inside of the lid and poke a small hole in the middle of the cardboard. Thread a string through the hole and tie a knot in the string. Put the cardboard, with the string hanging from it, back into the lid of the jar. Tie a film clip to the string, and you've made your own Diazochrome film developing tank.

Diazochrome film is developed in ammonia fumes. You'll need to use 28% concentrated ammonium hydroxide, which you can buy from your pharmacist. Household ammonia is not strong enough. Since it is the fumes that develop the film, you'll need only a small amount of solution.

You can make a developing tank from a large jar with a screw-on lid. To keep the film from touching the solution, suspend a short piece of string from the top of the jar and tie a film clip to the end of it. The film clip will hold your Diazochrome film above the liquid while it is being developed in the ammonia fumes. Be sure to cover your nose and mouth when opening the jar because ammonia fumes are very irritating when inhaled. Work in a well-ventilated area. If the film accidentally gets wet, wipe it with a soft cloth.

Develop the film for 4 minutes. Actually, some colors of Diazochrome film develop in less time, but I prefer to develop my film for 4 minutes to get the most saturated colors.

To complete the procedure, mount the Diazochrome film with the original slide in a KODAK Mask and glass slide mount. You can arrange the two pieces of film either in or out of register, depending on the effect you're trying to achieve. You can use the high-contrast negative over and over again with other colors of Diazochrome film.

Sources of materials:

Diazochrome Film: Technifax Corporation
195 Appleton Street
Holyoke, Massachusetts 01040

KODAK Professional Line Copy Film 6573,
KODAK EKTACHROME Infrared Film, Size 135, and
KODAK HIGH-LINE Developer:
Photo Dealers

Carl Dumbauld is Director of Photo Information in Kodak's Consumer Markets Division. His department provides photographic information to amateur photographers through slide and movie programs, television programs, youth photo programs, and thousands of letters weekly. Carl has worked in the field of professional photography, and as a former Director of Publications, he wrote and edited many Kodak publications on photography. He has a Bachelor of Fine Arts degree in Photographic Illustration from Rochester Institute of Technology.

A Practical Look at Movie Lenses
by Carl S. Dumbauld

If a psychiatrist were to read this article, he might suggest calling it "Understanding Your Lens." I must admit that it would be a very descriptive name indeed! But I thought the word "Practical" in the title would attract your attention, and practical this article is!* If you don't really understand some of the whys and wherefores of the lens (or lenses) on your movie camera, I believe you will 15 pages from now. Maybe your camera has interchangeable lenses, and you're not sure what the extra lenses can do for you. Maybe you've been using a zoom lens, and strange things have been happening, and you're not sure why. Perhaps you're in the market for a new lens or a new camera (or both), and you need some help in deciding what will best fill your needs. If any of these situations sounds familiar, read on!

*For a more technical discussion of lenses and some special hints on getting the most out of lenses for still cameras, you may want to read "Some Chit-Chat About Lenses" in *More Here's How,* KODAK Publication No. AE-83.

WHAT ABOUT FOCAL LENGTH?

To get the most out of your movie lenses, there are a few basic terms you must understand. "Focal length" is one term that is much talked about but not always understood. Because we're interested in the practical use of lenses, I won't get bogged down in a lot of technical jargon. But it is important to know what focal length really means. It's even more important to know what lenses of different focal lengths can do for you.

First, what does focal length mean? Practically speaking, the light reflected from a point at infinity falls on the front of the camera lens as parallel rays. The lens (focused on infinity) bends the rays of light so that they converge behind the lens to form an image of the point from which they originated. The distance between the image of that point and roughly the center of the lens (actually the rear nodal point, but let's not get into that!) is the focal length of the lens.

Now let's get to the crux of the matter. What can knowledge of focal length do for you? The focal length of the lens determines the size of the subject's image formed on the film. When the distance between the camera and the subject remains unchanged, a change in the focal length of the lens is proportional to the change in the size of the subject's image.

I said I was going to be practical, didn't I? Okay, for an example let's assume you're taking movies with a 6.5 mm lens on your camera. There is a red barn in the scene. Now, without changing your distance from the barn you switch to a 13 mm lens. The image of the barn will be twice as big. Simple, isn't it? The pictures below show what happens to image size when you change from a lens of one focal length to another, or when you change the focal length of a zoom lens.

| 6.5 mm lens | 13 mm lens | 27 mm lens |

Measure the barn in the pictures representing the 6.5 mm and 13 mm lenses. You'll find the barn is twice as big in the picture representing the 13 mm lens. Measure the barn in the picture representing the 27 mm lens. In this picture the barn is just slightly more than 4 times as large as the barn in the picture representing the 6.5 mm lens. The subject distance was the same for each picture. Of course, as the image size of the barn increases, the area included in the picture decreases.

66

Just for the record, I'll end this section by mentioning the obvious. I said that as focal length increases, image size increases. As image size increases, the area included in the picture must be less (see pictures at bottom of page 66). In other words, as illustrated below, when focal length increases, the angular field covered by the lens decreases.

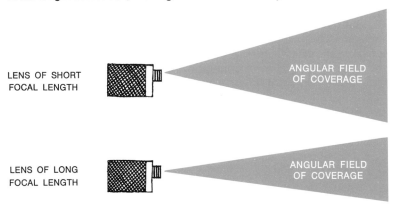

WHAT ABOUT DEPTH OF FIELD?

"Depth of field" means the area which *appears* to be in focus in front of and behind the subject on which the camera is focused.

Theoretically, when you make a movie and you focus on a lamppost 25 feet away, only the lamppost will be in focus. Any point in the scene that is closer or farther away than 25 feet will not be registered as a point on the film. Instead, it will be registered on the film as a small blurred circle. Such circles are called "circles of confusion." This is illustrated in the diagram below. The farther the point in the scene is from the point focused upon, the larger the circle of confusion becomes.

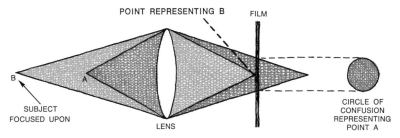

The red point (A) is not the same distance from the camera as the point focused upon (B). Both points cannot come to focus at the same distance behind the lens. Therefore, the red point will be registered on the film as a circle rather than as a point.

Considering this example from our practical viewpoint, you and I know that some things in front of and some things behind the lamppost will look sharp when the movie is projected. What really concerns us is how big the circles of confusion can become before the picture no longer *looks* sharp. When this point is reached, the subject is no longer within the depth of field. In computing the depth of field for Kodak movie lenses, a circle of confusion of .001 inch in diameter is used for 16 mm cameras, .0005 inch is used for 8 mm cameras, and .00065 inch is used for super 8 cameras. Of course, tables based on circles of confusion of other sizes would vary from those we've printed on pages 69 to 76.

When you look at the depth-of-field tables on pages 69 to 76, remember that the picture doesn't suddenly become fuzzy at the depth-of-field extremes. Let's assume you've focused on a subject 10 feet away, and the depth of field is from 7 feet to 15 feet. The circles of confusion will be smallest at 10 feet. They will gradually become larger and pass the sizes of the circles of confusion mentioned above at 7 feet and 15 feet.

Now that you know the basis of depth of field, we'll look at the factors that control depth of field. Depth of field becomes greater as (1) the focal length of the lens decreases (subject distance remaining unchanged), (2) the size of the lens opening decreases, and (3) the subject distance increases.

***HOW FOCAL LENGTH AFFECTS DEPTH OF FIELD**

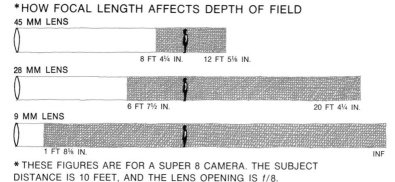

45 MM LENS

8 FT 4¼ IN. 12 FT 5⅛ IN.

28 MM LENS

6 FT 7½ IN. 20 FT 4¼ IN.

9 MM LENS

1 FT 8⅛ IN. INF

* THESE FIGURES ARE FOR A SUPER 8 CAMERA. THE SUBJECT DISTANCE IS 10 FEET, AND THE LENS OPENING IS *f*/8.

†HOW LENS OPENING AFFECTS DEPTH OF FIELD

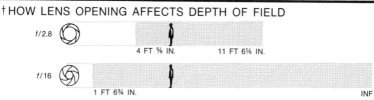

f/2.8

4 FT ⅝ IN. 11 FT 6⅛ IN.

f/16

1 FT 6¾ IN. INF

†THESE FIGURES ARE FOR A SUPER 8 CAMERA. THE LENS HAS A 13 MM FOCAL LENGTH, AND THE SUBJECT DISTANCE IS 6 FEET.

3 FT 3⅜ IN. 5 FT

6 FT 7½ IN. 20 FT 4¼ IN.

10 FT 11⅝ IN. INF

*THESE FIGURES ARE FOR A SUPER 8 CAMERA. THE LENS HAS A 28 MM FOCAL LENGTH, AND THE LENS OPENING IS f/8.

From looking over these illustrations, you can see there are times when focusing is most critical because depth of field is slight. These times include situations in which you use a long-focal-length lens or a large lens opening, or when you are close to your subject.

Of course, a combination of these factors would make accurate focusing even more important. For example, assume you are using a 45 mm lens on a super 8 camera to make movies of a subject only 4 feet away. At a lens opening of f/4, your depth of field would be from 3 feet 10⅛ inches to 4 feet 1⅞ inches. Critical focusing required? You said it!

DEPTH-OF-FIELD TABLES*

For Super 8 Cameras

The distances given in these tables are measured from the film plane. These tables are based on a circle of confusion of .00065 inch.

9 mm Lens

Distance Focused On (in feet)		f/2.7		f/4		f/5.6		f/8		f/11		f/16	
		ft.	in.	ft.	in.	ft.	in.	ft.	in.	ft.	in.	ft.	in.
∞ (INF)	NEAR	5	11⅜	4	¼	2	10⅜	2	⅛	1	5½	1	0
	FAR	∞		∞		∞		∞		∞		∞	
25	NEAR	4	9¾	3	5⅝	2	6⅞	1	10¼	1	4½	0	11½
	FAR	∞		∞		∞		∞		∞		∞	
15	NEAR	4	3¼	3	2⅛	2	4⅞	1	9¼	1	4	0	11¼
	FAR	∞		∞		∞		∞		∞		∞	
10	NEAR	3	8⅞	2	10½	2	2¾	1	8⅛	1	3¼	0	10⅞
	FAR	∞		∞		∞		∞		∞		∞	
6	NEAR	2	11⅞	2	4⅞	1	11⅜	1	6⅛	1	2⅛	0	10⅜
	FAR	∞		∞		∞		∞		∞		∞	
4	NEAR	2	4¼	2	⅛	1	8⅛	1	4⅛	1	⅞	0	9⅝
	FAR	11	11⅝	∞		∞		∞		∞		∞	

*These depth-of-field tables are based on circular lens apertures. Since the apertures in cameras with automatic exposure-control systems are seldom circular, use these tables only as guides with such cameras.

13 mm Lens

Distance Focused On (in feet)		f/2.8 ft.	in.	f/4 ft.	in.	f/5.6 ft.	in.	f/8 ft.	in.	f/11 ft.	in.	f/16 ft.	in.
∞ (INF)	NEAR	12	5	8	4⅝	5	11⅞	4	2¼	3	⅝	2	1⅛
	FAR	∞		∞		∞		∞		∞		∞	
25	NEAR	8	3¾	6	3½	4	10	3	7⅛	2	8⅝	1	11¼
	FAR	∞		∞		∞		∞		∞		∞	
15	NEAR	6	9⅝	5	4⅝	4	3½	3	3⅜	2	6½	1	10⅛
	FAR	∞		∞		∞		∞		∞		∞	
10	NEAR	5	6⅝	4	6⅞	3	9	2	11½	2	4⅛	1	8⅞
	FAR	50	1½	∞		∞		∞		∞		∞	
6	NEAR	4	⅝	3	6	3	0	2	5¾	2	⅜	1	6¾
	FAR	11	6⅛	20	7⅛	∞		∞		∞		∞	
4	NEAR	3	⅜	2	8½	2	4⅞	2	⅝	1	8⅞	1	4⅝
	FAR	5	10⅜	7	6¾	11	9⅛	69	9½	∞		∞	

28 mm Lens

Distance Focused On (in feet)		f/2.7 ft.	in.	f/4 ft.	in.	f/5.6 ft.	in.	f/8 ft.	in.	f/11 ft.	in.	f/16 ft.	in.
∞ (INF)	NEAR	57	4⅜	38	9½	27	8⅞	19	5⅛	14	1⅛	9	8⅝
	FAR	∞		∞		∞		∞		∞		∞	
25	NEAR	17	5½	15	2⅞	13	2¼	10	11⅝	9	⅝	7	¼
	FAR	43	11¾	69	4⅛	∞		∞		∞		∞	
15	NEAR	11	11	10	10⅛	9	9⅛	8	5⅞	7	3⅝	5	11
	FAR	20	2⅝	24	3½	32	3¾	63	11⅝	∞		∞	
10	NEAR	8	6⅜	7	11⅝	7	4⅜	6	7½	5	10½	4	11⅜
	FAR	12	⅞	13	4⅞	15	6⅜	20	4¼	33	3⅜	∞	
6	NEAR	5	5¼	5	2½	4	11⅜	4	7⅛	4	2¾	3	8¾
	FAR	6	8⅛	7	¾	7	7⅜	8	7¼	10	3½	15	3
4	NEAR	3	8⅞	3	7½	3	6	3	3⅜	3	1½	2	10¼
	FAR	4	3⅜	4	5¼	4	7¾	5	0	5	6¼	6	8⅛

36 mm Lens

Distance Focused On (in feet)		f/2.7 ft.	in.	f/4 ft.	in.	f/5.6 ft.	in.	f/8 ft.	in.	f/11 ft.	in.	f/16 ft.	in.
∞ (INF)	NEAR	94	5¾	63	11⅝	45	9¼	32	1	23	4¼	16	¾
	FAR	∞		∞		∞		∞		∞		∞	
25	NEAR	19	9⅞	18	⅜	16	2⅝	14	1⅛	12	1⅜	9	9¾
	FAR	33	9⅞	40	8⅞	54	5⅝	110	1	∞		∞	
15	NEAR	12	11⅝	12	2⅛	11	3⅞	10	3	9	2	7	9½
	FAR	17	9¼	19	6	22	2	27	10⅜	41	2	198	9⅞
10	NEAR	9	⅝	8	8	8	2¾	7	7¾	7	⅜	6	2¼
	FAR	11	1¾	11	9¾	12	8¾	14	5⅛	17	3⅜	25	10¼
6	NEAR	5	7¾	5	5⅞	5	3¾	5	⅞	4	9½	4	4⅝
	FAR	6	4⅝	6	7⅛	6	10½	7	4	8	⅛	9	5⅜
4	NEAR	3	10	3	9¼	3	8¼	3	6¾	3	5⅛	3	2⅝
	FAR	4	2	4	3	4	4⅜	4	6½	4	9½	5	3¼

45 mm Lens

Distance Focused On (in feet)		f/2.7 ft.	f/2.7 in.	f/4 ft.	f/4 in.	f/5.6 ft.	f/5.6 in.	f/8 ft.	f/8 in.	f/11 ft.	f/11 in.	f/16 ft.	f/16 in.
∞ (INF)	NEAR	146	10½	99	7⅛	71	4⅛	50	½	36	5⅜	25	1
	FAR	∞		∞		∞		∞		∞		∞	
25	NEAR	21	5	20	½	18	6⅛	16	8¾	14	10⅝	12	6⅞
	FAR	30	0	33	2⅜	38	2½	49	4⅞	77	11½	∞	
15	NEAR	13	7⅝	13	¾	12	5⅛	11	6⅛	10	8	9	5⅛
	FAR	16	7⅞	17	7⅛	18	10⅞	21	3⅜	25	3	36	7½
10	NEAR	9	4½	9	1¼	8	9½	8	4¼	7	10½	7	2⅛
	FAR	10	8⅜	11	1	11	7	12	5⅛	13	8⅛	16	5¼
6	NEAR	5	9¼	5	8	5	6½	5	4⅜	5	2	4	10⅜
	FAR	6	2⅞	6	4⅜	6	6⅜	6	9⅜	7	1⅝	7	9¾
4	NEAR	3	10¾	3	10⅛	3	9½	3	8½	3	7⅜	3	5½
	FAR	4	1¼	4	1⅞	4	2⅝	4	3⅞	4	5⅝	4	8⅛

For 8 mm Cameras

The distances given in the following tables are measured from the film plane in the camera. These tables are based on a circle of confusion of .0005 inch.

6.5 mm Lens

Distance Focused On (in feet)		f/2.7 ft.	f/2.7 in.	f/4 ft.	f/4 in.	f/5.6 ft.	f/5.6 in.	f/8 ft.	f/8 in.	f/11 ft.	f/11 in.	f/16 ft.	f/16 in.
∞ (INF)	NEAR	4	⅜	2	8⅝	1	11⅜	1	4¼	0	11⅞	0	8⅛
	FAR	∞		∞		∞		∞		∞		∞	
25	NEAR	3	5¾	2	5½	1	9⅝	1	3½	0	11⅜	0	7⅞
	FAR	∞		∞		∞		∞		∞		∞	
15	NEAR	3	2¼	2	3⅝	1	8⅝	1	3	0	11⅛	0	7¾
	FAR	∞		∞		∞		∞		∞		∞	
10	NEAR	2	10½	2	1¾	1	7½	1	2⅜	0	10¾	0	7⅝
	FAR	∞		∞		∞		∞		∞		∞	
6	NEAR	2	5	1	10½	1	5⅝	1	1⅜	0	10⅛	0	7¼
	FAR	∞		∞		∞		∞		∞		∞	
4	NEAR	2	⅛	1	7½	1	3¾	1	¼	0	9½	0	7
	FAR	253	6⅝	∞		∞		∞		∞		∞	

9 mm Lens

Distance Focused On (in feet)		f/2.7		f/4		f/5.6		f/8		f/11		f/16	
		ft.	in.	ft.	in.	ft.	in.	ft.	in.	ft.	in.	ft.	in.
∞ (INF)	NEAR	7	8⅞	5	2⅝	3	8¾	2	7⅜	1	10¾	1	3⅝
	FAR	∞		∞		∞		∞		∞		∞	
25	NEAR	5	11	4	3⅞	3	3	2	4⅜	1	9⅛	1	2⅞
	FAR	∞		∞		∞		∞		∞		∞	
15	NEAR	5	1⅜	3	10½	2	11⅞	2	2¾	1	8¼	1	2⅜
	FAR	∞		∞		∞		∞		∞		∞	
10	NEAR	4	4⅜	3	5¼	2	8⅝	2	⅞	1	7⅛	1	1⅞
	FAR	∞		∞		∞		∞		∞		∞	
6	NEAR	3	4⅝	2	9½	2	3⅝	1	9⅞	1	5⅝	1	⅞
	FAR	26	1½	∞		∞		∞		∞		∞	
4	NEAR	2	7⅝	2	3¼	1	11¼	1	7	1	3½	0	11⅞
	FAR	8	2⅜	16	7⅛	∞		∞		∞		∞	

13 mm Lens

Distance Focused On (in feet)		f/2.7		f/4		f/5.6		f/8		f/11		f/16	
		ft.	in.	ft.	in.	ft.	in.	ft.	in.	ft.	in.	ft.	in.
∞ (INF)	NEAR	16	1⅝	10	10¾	7	9⅜	5	5¾	3	11½	2	8⅝
	FAR	∞		∞		∞		∞		∞		∞	
25	NEAR	9	9⅞	7	7¼	5	11⅜	4	5¾	3	5⅛	2	5½
	FAR	∞		∞		∞		∞		∞		∞	
15	NEAR	7	9½	6	3⅞	5	1⅝	4	0	3	1⅛	2	3¾
	FAR	∞		∞		∞		∞		∞		∞	
10	NEAR	6	2¼	5	2¾	4	4⅝	3	6⅜	2	10⅛	2	1¾
	FAR	26	¼	114	⅛	∞		∞		∞		∞	
6	NEAR	4	4½	3	10½	3	4¾	2	10⅜	2	4¾	1	9¼
	FAR	9	6	13	2¼	25	5¼	∞		∞		∞	
4	NEAR	3	2½	2	11⅛	2	7¾	2	3¾	2	0	1	7½
	FAR	5	3½	6	3¼	8	1⅜	14	6⅝	∞		∞	

30 mm Lens

Distance Focused On (in feet)		f/2.7 ft.	in.	f/4 ft.	in.	f/5.6 ft.	in.	f/8 ft.	in.	f/11 ft.	in.	f/16 ft.	in.
∞ (INF)	NEAR	85	4½	57	9⅜	41	4⅛	28	11⅝	21	1	14	6
	FAR	∞		∞		∞		∞		∞		∞	
50	NEAR	31	7¾	26	10¾	22	8⅜	18	4¾	14	10½	11	3¼
	FAR	118	10⅞	∞		∞		∞		∞		∞	
25	NEAR	19	4⅝	17	6	15	7½	13	5½	11	5⅝	9	2½
	FAR	35	2	43	8¾	62	5½	174	7¼	∞		∞	
15	NEAR	12	9⅜	11	11¼	11	⅜	9	10⅞	8	9½	7	4¾
	FAR	18	1⅝	20	2	23	4¾	30	9⅜	50	10⅛	∞	
10	NEAR	8	11½	8	6½	8	⅞	7	5⅛	6	9⅝	5	11¼
	FAR	11	3½	12	⅝	13	1½	15	2	18	9¾	31	4⅝
6	NEAR	5	7⅜	5	5¼	5	3	4	11¾	4	8¼	4	3⅛
	FAR	6	5¼	6	8⅛	6	11⅞	7	3¼	8	3⅞	10	1⅛
4	NEAR	3	9⅞	3	8⅞	3	7⅞	3	6¼	3	4½	3	1¾
	FAR	4	2¼	4	3⅜	4	4⅞	4	7⅜	4	10¾	5	5½

For 16 mm Cameras

The distances given in the following tables are measured from the film plane in the camera. These tables are based on a circle of confusion of .001 inch.

15 mm Lens

Distance Focused On (in feet)		f/2.8 ft.	in.	f/4 ft.	in.	f/5.6 ft.	in.	f/8 ft.	in.	f/11 ft.	in.	f/16 ft.	in.	f/22 ft.	in.
∞ (INF)	NEAR	11	7	8	2	5	10	4	1	3	0	2	1	1	6
	FAR	∞		∞		∞		∞		∞		∞		∞	
12	NEAR	5	11	4	10	3	11	3	1	2	5	1	10	1	4
	FAR	∞		∞		∞		∞		∞		∞		∞	
6	NEAR	4	0	3	6	3	0	2	6	2	0	1	7	1	3
	FAR	12	2	21	0	∞		∞		∞		∞		∞	
4	NEAR	3	¼	2	8½	2	5	2	¾	1	9	1	5	1	2
	FAR	6	0	7	8	12	2	104	6	∞		∞		∞	
2	NEAR	1	8¾	1	7⅝	1	6¼	1	4½	1	3	1	¾	0	10⅞
	FAR	2	4½	2	7⅛	2	11⅜	3	8½	5	6	29	11	∞	

25 mm Lens

Distance Focused On (in feet)		f/2.8		f/4		f/5.6		f/8		f/11		f/16		f/22	
		ft.	in.	ft.	in.	ft.	in.	ft.	in.	ft.	in.	ft.	in.	ft.	in.
∞ (INF)	NEAR	30	0	21	0	15	0	10	6	7	9	5	4	4	0
	FAR	∞		∞		∞		∞		∞		∞		∞	
30	NEAR	15	0	12	0	10	0	7	10	6	2	4	6	3	6
	FAR	∞		∞		∞		∞		∞		∞		∞	
15	NEAR	10	0	9	0	7	6	6	3	5	2	4	0	3	2
	FAR	29	0	50	0	∞		∞		∞		∞		∞	
10	NEAR	7	6	6	10	6	0	5	2	4	5	3	6	2	10
	FAR	14	10	18	9	29	0	155	0	∞		∞		∞	
6	NEAR	5	0	4	8	4	4	3	10	3	5	2	10	2	5
	FAR	7	5	8	3	9	9	13	6	25	0	∞		∞	
4	NEAR	3	7	3	5	3	2¼	2	11	2	8	2	4	2	0
	FAR	4	7	4	10	5	4¼	6	3	8	0	15	0	∞	
2	NEAR	1	10¾	1	10¼	1	9½	1	8⅝	1	7½	1	6	1	4½
	FAR	2	1½	2	2	2	3	2	5	2	7	3	0	3	9½

50 mm Lens

Distance Focused On (in feet)		f/2.8		f/4		f/5.6		f/8		f/11		f/16		f/22	
		ft.	in.	ft.	in.	ft.	in.	ft.	in.	ft.	in.	ft.	in.	ft.	in.
∞ (INF)	NEAR	120	0	80	0	60	0	40	0	30	0	20	0	15	0
	FAR	∞		∞		∞		∞		∞		∞		∞	
50	NEAR	35	0	30	0	25	0	20	0	18	0	14	0	12	0
	FAR	80	0	100	0	300	0	∞		∞		∞		∞	
25	NEAR	21	0	20	0	18	0	16	0	14	0	12	0	10	0
	FAR	32	0	35	0	40	0	60	0	150	0	∞		∞	
15	NEAR	13	3	13	0	12	0	11	0	10	0	9	0	8	0
	FAR	17	0	18	0	20	0	25	0	30	0	40	0	∞	
10	NEAR	9	0	8	9	8	6	8	0	7	6	7	0	6	0
	FAR	10	8	11	0	12	0	13	0	15	0	20	0	30	0
6	NEAR	5	8	5	7	5	6	5	4	5	0	4	8	4	4
	FAR	6	4	6	6	6	9	7	2	7	6	8	6	10	0
4	NEAR	3	10½	3	9½	3	9	3	8	3	7	3	5	3	3
	FAR	4	1½	4	2	4	3	4	4	4	5	4	11	5	6

63 mm Lens

Distance Focused On (in feet)		f/2.8		f/4		f/5.6		f/8		f/11		f/16		f/22	
		ft.	in.	ft.	in.	ft.	in.	ft.	in.	ft.	in.	ft.	in.	ft.	in.
∞ (INF)	NEAR	200	0	140	0	90	0	65	0	48	0	33	0	25	0
	FAR	∞		∞		∞		∞		∞		∞		∞	
50	NEAR	40	0	35	0	33	0	30	0	25	0	20	0	16	0
	FAR	68	0	80	0	100	0	200	0	∞		∞		∞	
25	NEAR	22	0	21	0	20	0	18	0	16	0	14	0	12	0
	FAR	28	0	30	0	33	0	40	0	60	0	100	0	∞	
15	NEAR	14	0	13	6	13	0	12	0	11	0	10	0	9	0
	FAR	16	0	17	0	18	0	19	0	21	0	25	0	40	0
10	NEAR	9	6	9	3	9	0	8	6	8	0	7	6	7	0
	FAR	10	6	10	9	11	0	12	0	12	6	13	0	15	0
6	NEAR	5	10	5	9	5	8	5	6	5	3	5	0	4	9
	FAR	6	2	6	3	6	5	6	7	6	9	7	0	7	6
4	NEAR	3	11	3	10½	3	10	3	9½	3	8½	3	7½	3	6
	FAR	4	1	4	1½	4	2	4	3	4	4	4	6	4	8

102 mm Lens

Distance Focused On (in feet)		f/2.7		f/4		f/5.6		f/8		f/11		f/16		f/22	
		ft.	in.	ft.	in.	ft.	in.	ft.	in.	ft.	in.	ft.	in.	ft.	in.
∞ (INF)	NEAR	500	0	300	0	200	0	170	0	120	0	85	0	60	0
	FAR	∞		∞		∞		∞		∞		∞		∞	
100	NEAR	85	0	80	0	70	0	65	0	55	0	46	0	40	0
	FAR	125	0	140	0	170	0	250	0	600	0	∞		∞	
50	NEAR	46	0	44	0	42	0	38	0	35	0	31	0	27	0
	FAR	55	0	60	0	65	0	70	0	85	0	125	0	300	0
30	NEAR	28	0	27	6	27	0	25	6	24	0	22	0	20	0
	FAR	32	0	33	0	34	0	36	5	40	0	50	0	60	0
20	NEAR	19	3	18	11	18	6	17	11	17	0	16	3	15	0
	FAR	20	10	21	3	21	9	22	7	23	9	26	0	30	0
15	NEAR	14	7	14	4	14	2	13	10	13	5	12	9	12	0
	FAR	15	5	15	8	16	0	16	5	17	0	18	0	20	0
8	NEAR	7	11	7	10	7	9	7	8	7	6	7	4	7	2
	FAR	8	1½	8	2	8	3	8	4½	8	6	8	9	9	0
6	NEAR	5	11¼	5	11	5	10½	5	10	5	9	5	8	5	6
	FAR	6	¾	6	1	6	1½	6	2	6	3½	6	5	6	7

152 mm Lens

Distance Focused On (in feet)		f/4		f/5.6		f/8		f/11		f/16		f/22	
		ft.	in.	ft.	in.	ft.	in.	ft.	in.	ft.	in.	ft.	in.
∞ (INF)	NEAR	800	0	540	0	375	0	275	0	190	0	140	0
	FAR	∞		∞		∞		∞		∞		∞	
200	NEAR	160	0	140	0	130	0	120	0	100	0	80	0
	FAR	270	0	300	0	425	0	700	0	∞		∞	
100	NEAR	90	0	85	0	80	0	74	0	65	0	60	0
	FAR	110	0	120	0	140	0	160	0	200	0	360	0
60	NEAR	56	0	54	0	52	0	50	0	46	0	40	0
	FAR	65	0	67	0	70	0	75	0	90	0	100	0
40	NEAR	38	0	37	4	36	0	35	0	33	0	30	0
	FAR	42	0	43	0	44	0	46	6	50	0	55	0
20	NEAR	19	6½	19	4	19	0	18	9	18	3	18	0
	FAR	20	6	20	8	21	0	21	6	22	0	23	0
12	NEAR	11	10½	11	9	11	8	11	7	11	4	11	2
	FAR	12	1½	12	3	12	4	12	6	12	8	13	0
8	NEAR	7	11¼	7	11	7	10½	7	10	7	9	7	8
	FAR	8	¾	8	1	8	1½	8	2¼	8	3¼	8	4½

"NORMAL" LENSES

Perhaps you have compared the view seen through the viewfinder of a 35 mm still camera with the view seen through the viewfinder of a movie camera (both with "normal" lenses). If so, you may have been surprised to notice that the still camera viewfinder included a larger area. Obviously, this is because the angular field covered by the normal lens on a movie camera is smaller than that covered by the normal lens on a still camera. But why this difference?

One reason camera designers chose a lens with a smaller angle of coverage to be the normal lens on a movie camera is so that you can place your movie camera farther from your subject when you're shooting, and still maintain a large image size. This additional space between the camera and the subject leaves the subject more free to move about, as he should in movies. Also, when the subject is at some distance from the camera he can move nearer or farther from the camera without an appreciable change in image size. For example, if the subject is 12 feet away from the camera and moves 3 feet closer, the image size becomes only ¼ larger. If the subject is 6 feet away and moves 3 feet closer, the image size becomes twice as large.

There's another reason why camera designers felt that the normal lens on a movie camera should cover a smaller angular field than is covered by the normal lens on a still camera. In a movie there is action taking place and the scene is changing frequently, so your eyes don't have time to scan as large an area as they do when you look at still pictures. Because of this, camera designers chose normal lenses for movie cameras with an angular field approximately equal to the angle of conscious vision of the human eye. Thus a 25 mm lens is normal for 16 mm cameras, and a 13 mm lens is normal for 8 mm cameras. When super 8 cameras were introduced (with their larger format), 13 mm was retained as normal; however, because of an increasing interest in lenses that encompass a wider field, a 9 mm lens is considered "normal" on most recent super 8 cameras.

LONG-FOCAL-LENGTH LENS (Telephoto Lens)

From this point forward, I'm going to join the millions of people who call a long-focal-length lens a "telephoto" lens. This terminology isn't quite correct. In the strict sense of the word, a telephoto lens is a specially constructed lens in which the total physical length is less than the focal length. However, for the sake of simplicity, I'll call a long-focal-length lens a telephoto lens, too.

A telephoto lens has a focal length greater than the focal length of the normal lens for the camera. While a 25 mm lens is a normal lens on a 16 mm camera, it would be a telephoto lens on a super 8 or 8 mm camera.

As I've already illustrated, you would choose a telephoto lens if you wanted to get a larger image size from a fixed camera-to-subject distance. Remember, though—a telephoto lens magnifies camera movement as well as image size. The camera movement is magnified the same amount the image size is increased. The same amount of camera "jiggle" would appear about twice as great with a 25 mm lens as with a 13 mm lens. The moral of this story is to use a tripod with a telephoto lens.

Also remember that depth of field is less with a telephoto lens than with a normal lens, so focus carefully!

WIDE-ANGLE LENS

The wide-angle lens for your camera is one with a focal length shorter than that of the normal lens. You would choose the wide-angle lens for greater angular coverage or to increase the depth of field (when you aren't concerned about decreasing image size).

ZOOM LENS

A zoom lens is a lens of variable focal length. It's a wide-angle, normal, and telephoto lens all in one. You're not restricted to these three positions, either. You can set the focal length to any position between the wide-angle and telephoto extremes. Add to this the convenience and economy of using one lens instead of three, and you'll understand the popularity of the zoom lens.

The focal-length range of a zoom lens is often referred to as a ratio. For example, if the range of a zoom lens is from 9 mm to 45 mm, it has a 5:1 ratio. This means that zooming from the wide-angle position to the telephoto position increases the image size five times.

For most of your movie-making, you should look through the camera viewfinder and adjust the focal length of the zoom lens to cover the area you want to photograph *before* you take pictures. Of course, you can also zoom the lens from one position to another while you are taking pictures. I'll add my plea to that of viewers everywhere—don't overdo the zooming! Zooming can be very effective, but if you zoom too much, the members of your audience will begin to feel as if they are on a long roller-coaster ride.

You don't always have to zoom *in* on your subject. When your subject is appropriate, set the lens at its telephoto position so that some detail of the subject fills the frame. Then zoom to the wide-angle position to show the complete subject. For example, if you are

The KODAK XL360 Movie Camera has a 9 to 21 mm zoom lens. This means the lens has a ratio of 2.3:1. With the lens in the 21 mm position, the image size of a given subject is more than twice as large as it is when the lens is in the 9 mm position.

making a fishing movie, make a shot with the lens in the telephoto position, showing the fisherman baiting the hook. As he completes baiting the hook, zoom to the wide-angle position to show the entire fisherman as he begins to cast.

The principles of focusing that apply to interchangeable lenses also apply to zoom lenses. The depth-of-field tables on pages 69 to 76 are applicable to zoom lenses set at the focal lengths listed. Because of the greater depth of field you get with a wide-angle lens, focusing is not so critical when the zoom lens is in the wide-angle position. When the zoom lens is in the telephoto position, critical focusing becomes very important. This accounts for an effect that baffles some moviemakers just beginning to use a zoom lens. Even though a zoom lens is not focused critically in the wide-angle position, the subject may still be acceptably sharp because of the great depth of field. But if the lens is then zoomed to the telephoto position, the depth of field is decreased and the subject may fall outside the depth of field. The result—a sharp picture that goes out of focus as the lens is zoomed to the telephoto position. The lesson here is simple. Always focus carefully—be particularly critical when using the telephoto position.

VARIETY THROUGH LENSES

You can use interchangeable lenses and zoom lenses to add variety, impact, and interest to your movies. The pace of your movies will begin to drag if the image size is always the same and if all the shots are made from the same angle. One way to change image size is by using lenses of different focal length. Intermix overall or "long" shots with "medium" shots, and don't overlook the impact of detail or "close-up" shots.

When you change image size, change the angle you're shooting from, too. Let's assume you're making a movie of a boy building a sand castle on the beach. Open with a long shot. Include the boy, the castle, and enough of the surrounding area to establish the location. (You can use a wide-angle lens so that you don't have to run way down the beach to make this shot.) Follow this with a medium shot including only the boy and the castle. To change the angle, shoot from a point slightly behind the boy to show him working on his project. (You can use a telephoto lens if you want to make this shot from a distance.) The close-up shot can be made from a high viewpoint, showing the boy's hands doing some detailed work. Follow this with another close-up from a very low viewpoint, looking up at the intent expression on the boy's face. This is the kind of variety that makes a movie dynamic.

Now *YOU* be practical—put your lenses to work!

"Alas, poor Yorick." John W. McFarlane, FPSA, observes a piston from his own antique Rolls-Royce. McFarlane is the retired Managing Editor of Kodak's Consumer Markets Publications. His first article in the *Here's How* series, "Some Chit-Chat About Lenses," appeared in *More Here's How* (KODAK Publication No. AE-83).

How to Photograph Antique Cars
by John W. McFarlane

Most people like cars. Some are as enthusiastic about cars as you and I are about photography. Among the objects of their affection are antique cars, classic cars, sports cars, and special-interest cars. The antique-car hobby is growing tremendously. The largest American club has more than 30,000 members.

No sharp dateline divides antique cars from others. The pre-1914 cars with brass trim are obviously antiques; they are perhaps the most spectacular ones to see and photograph. Some later cars are also considered antiques. Hobbyists are restoring cars of the 30's and 40's. For example, car clubs have a special competition class for Model A Fords. The term "classic" generally means luxury cars of the 20's and perhaps as late as the 40's. Both antiques and classics represent a heavy investment of time and money for the owners. A well-restored 1910 Model T Ford, for example, may change hands at $6,000. Most owners of antique cars lavish great care on them, take them seriously, and drive them carefully.

PHOTOGRAPHIC OBJECTIVES

Applying your photographic hobby to another hobby is really fun! Antique cars offer a new challenge in colorful subjects. Some pictures of car details are appearing in photographic salons. Who knows, the steering wheel may replace the wagon wheel! Perhaps a related collection of pictures will interest you, such as a collection of photos of different types of acetylene headlamps. Another collection might contain pictures of as many different models and years of a certain-make car as you can find—say, Cadillac. Perhaps you have a friend who is setting out to restore an antique car. He may not take time to photograph his progress as he works. If you can make the necessary photographic history, both of you will value the results highly. There is also acceptance for good photographs of antique cars in magazines, both commercial and club. Slide shows on antique cars are quite popular, even with general audiences.

CAMERA, ACCESSORIES, AND FILM

In my opinion, a single-lens reflex camera is the most useful type of camera for photographing antique cars, partly because of its ability to make extreme close-ups that have been accurately focused and framed. You also need close-up lenses for a really close approach. Flash (either bulb or electronic) is needed for fill-in light outdoors and for most indoor shots.

Cars in the Ford Museum photographed by existing light at a small lens opening. A tripod was used.

A tripod is quite important for pictures of exhibits in museums, convention halls, etc. (Always check to make sure that a tripod is permitted.) These colorful subjects demand color film. KODAK EKTACHROME-X, KODACHROME 64 (Daylight), and KODACOLOR II Films are better to use than slower films whenever subject motion or poor light is involved. On the other hand, film of still higher speed presents a problem in taking close-ups with flash; you "run out of" small aperture! If you are taking existing-light pictures by tungsten light in a museum, use KODAK High Speed EKTACHROME Film (Tungsten)—film speed ASA 125. If the museum is illuminated predominantly by daylight, it's possible that you may be able to take hand-held shots with an f/2.8 or faster lens, using KODAK High Speed EKTACHROME Film (Daylight)—film speed ASA 160.

Kodak will push-process your High Speed EKTACHROME Film, sizes 135 and 120 only, to 2½ times its normal film speed—from ASA 160 to ASA 400 for Daylight type, and from ASA 125 to ASA 320 for Tungsten type. To get this service, purchase a KODAK Special Processing Envelope, ESP-1, from your photo dealer. (The purchase price for the envelope is in addition to the regular charge for KODAK EKTACHROME Film processing.) Return the exposed film in the ESP-1 Envelope to your photo dealer, or place the film and envelope in the appropriate KODAK Mailer and send it to the nearest Kodak Processing Laboratory. When you use the ESP-1 Envelope, be sure you have exposed the entire roll of film at the higher film speed.

HOW TO FIND ANTIQUE CARS

You have probably seen a parade or an auto show which included antique and classic cars. You may have seen a meet held by an antique-car club. Some meets are open to the public. Newspapers often announce these events. Most cities now have local antique-car clubs. You can locate these through local offices of the American Automobile Association. Consider joining a local club. Write to the

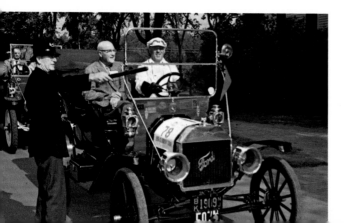

"Antique" policeman poses (at photographer's request) with 1909 Model T Ford, Greenfield Village.

club secretary (enclosing a self-addressed, stamped envelope) to obtain the necessary information.

The national clubs all publish excellent magazines and hold large meets and tours. Local clubs usually have calendars of events of national-club activities. One of the big events every year is the Glidden Tour. About 300 pre-1933 cars tour part of the United States. These cars are usually the best of the antiques. The drivers are usually willing, sometimes glad, to have their cars photographed.

You might seriously consider joining one of the national clubs to gain some good knowledge of antique cars and events. The largest nationwide club is the Antique Automobile Club of America, with headquarters at 501 W. Governor Road, Hershey, Pennsylvania 17033. Another is the Veteran Motor Car Club of America, Inc., which is most active in the East, with headquarters at 15 Newton Street, Brookline, Massachusetts 02146. The Horseless Carriage Club of America is largely western, with headquarters at 9031 East Florence Avenue, Arrington Square, Downey, California 90240.

There are car museums and large technical museums which include cars. Two of the latter are the Ford Museum in Dearborn, Michigan, and the Science Museum in Chicago. There is an annual "Old Car Festival" at Greenfield Village in Dearborn each September. It draws a lot of excellent antique cars.

COOPERATION FROM THE CAR OWNER

Before you approach a car owner, read up on antique cars either in antique-car magazines or in books available from your library. For example, you could read books on antique cars by Ralph Stein. Then an antique-car owner will know that you are sincerely and intelligently interested.

If the cars are roped off at a meet, don't go inside the ropes. Under no circumstances should you raise the hood or sit in the car. Don't touch any part of the car. Promise to send the owner photographs only if you know that you will carry through. If you are shooting slides, shoot duplicates for the owner. If the car is being judged at a meet, you may not get much cooperation until the judges have finished with the car.

PICTURE SITUATIONS

Let's start with what is sometimes the most trying picture situation: a moving parade. Stand where the sun will be behind you, lighting the oncoming cars. Be early enough to get in front of the crowd. Use a fast shutter speed to stop the motion of the cars.

Another situation is taking shots of cars on tour from a moving car.

If you have a choice, use a convertible with the top down. Stabilize your camera by attaching a tripod to it, but keep the tripod legs collapsed and folded together, and don't let them touch the car. Hold the camera with your right hand, the tripod legs with your left. Use a shutter speed of 1/250 or 1/500 second. Be sure your driver passes the antique cars with care so that you can get three-quarter views from the rear of your car. If you shoot pictures through the windshield, wear a peaked cap to keep sunlight off the top of your camera. Otherwise, sunlight can reflect onto the windshield and bounce back into the camera lens.

A typical picture situation is a large annual meet of 500 or more cars. The cars are parked close together and there are thousands of people. Groups of cars make interesting pictures, and you can get at least the front two-thirds of most of them. The "flea market" (area devoted to sale of car parts, etc) offers interesting picture possibilities, too.

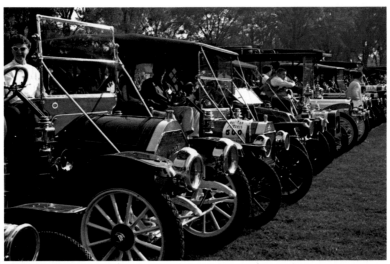

Antique-car lineup at the Old Car Festival. Backlighting adds sparkle to pictures such as this.

The Concours d'Elegance is a more formal meet, usually of classic cars, at which judging is on appearance alone. The Concours is a spectacular sight, and often the cars are well spaced in beautiful surroundings. Concours cars are usually in magnificent condition.

Earlier, we mentioned museums for interesting cars. Get permission for pictures, of course, and find out if tripods and/or flash pic-

tures are permitted in the museum. Take existing-light pictures, with camera on tripod, of cars or groups of cars. On the other hand, flash works out better for pictures of details, such as engines.

The best picture situation is the local meet in a rural area. Judging is not usual and there is a more relaxed air. You have a much better chance to become acquainted with the car owner. If properly approached, he may be willing to move his car for the best photographic angle.

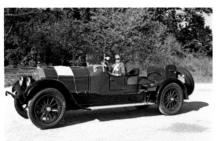

Modern vehicles and buildings in the background spoil the effect; foliage or sky is better.

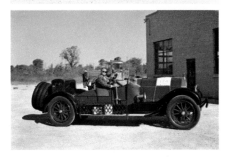

FLASH TECHNIQUE

Flash technique for pictures of cars differs from that for pictures of people. For one thing, cars are bigger than people—well, longer anyway. Another difference is that facial shadows are not as deep as shadows on cars. Fenders are deeper than eyebrows! Still another thing: polished people don't present reflection problems like polished cars do.

Flash pictures of cars require a stronger flash because the subject distance is greater. With a 64- or 80-speed film, a flashcube or an AG-1B bulb in a shallow reflector demands a very large lens aperture at the distance needed. A larger bulb in a polished-bowl reflector is more practical. This is true both indoors and outdoors, for fill-in flash. When possible, you can use an extension flash near the rear of the car to supplement the flash on the camera.

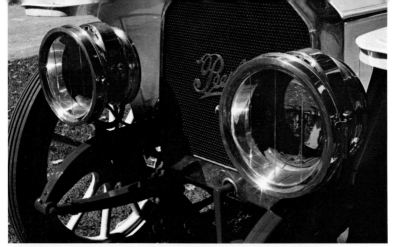

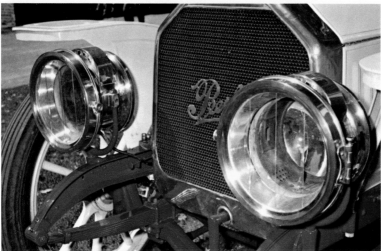

Gray and Davis acetylene headlights on a 1909 Peerless, with and without fill-in flash.

Shadows on a car need more fill-in light outdoors than do shadows on a face. As a working rule, choose the same lens aperture you would use for an indoor flash shot at the same distance, but use the right shutter time to give proper sunlight exposure. This technique assumes a camera that has full-range synchronization with bulbs, or "X-synch" with electronic flash.

As for reflections, anticipate and avoid them. This usually means shooting at an angle. A straight side view of a black car, taken with flash, usually gives a glaring reflection. So does a straight front view of a flat-tanked radiator.

PICTURE-MAKING WITH THE OWNER'S COOPERATION

Let's assume that you have an agreeable working arrangement with the car owner. First of all, get him to move the car to where there is a good background free of modern cars and modern buildings. Foliage is nearly always a good background—after all, 1905 foliage didn't look any different. It's possible to document a car quite well in five shots, plus close-ups of interesting details. The five shots are:

1. Three-quarters front from the driver's side, with the owner sitting in the car.

2. Three-quarters rear from the other side.

3. Instruments and controls taken from the back of the front seat. This picture needs fill-in flash unless the car is a very early open type.

4 and 5. Engine from each side. Both of these pictures will also need fill-in flash. There are always very dark pockets of shadow around the engine.

All of these five shots mean moving the car so that the part photographed will be in the sunlight.

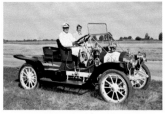
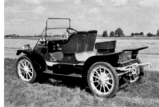

Documenting a car. Photograph both sides, the controls, and the engine. Make close-ups of front and rear, and extreme close-ups of any interesting details. Engine pictures need fill-in flash. This car is a 1911 Packard roadster, with "mother-in-law" seat.

Another type of picture (of more interest with classic cars) is the "coachwork" shot. This is a straight side-on shot made primarily to show the body outline. You should stand so that you are in line with the windshield, holding the camera lens at such a height that just a small part of the far door shows above the edge of the near door.

If an open car has a particularly interesting or beautiful upholstery job, it is shown best from a point about 8 to 10 feet above the ground. If possible, use a stepladder for this type of shot. Don't try standing on your own car—and especially not on the antique car itself.

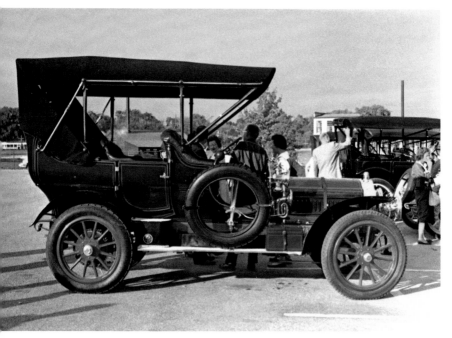

"Coachwork" shot of a 1907 Thomas Flyer. This photograph was made at an old-car festival held at Greenfield Village, Dearborn, Michigan.

Now for some close-ups of details: There are interesting parts—like headlights, sidelights, antique-type speedometers, bulb horns, acetylene generators, and (on many pre-1911 cars) the Selden patent license plate. (Selden had a basic patent for which most car manufacturers paid license fees, until Henry Ford defeated Selden about

1911 after a long patent suit.) These small details mean close-range focusing, in many cases with supplementary lenses. A close-up of an early-type Firestone tire is of interest. The tread says "NON SKID." Firestone still has the old molds and is now supplying these obsolete tire sizes.

Many classic cars are black; for these, you will need about double the exposure you would normally give. When you photograph a white car on slide film, give ½ stop less exposure than for an average subject.

If you are photographing people seated in a touring car with the top up, you will need flash; otherwise, the people's faces will be much too dark.

Speaking of people, at many car meets the owners of the older antiques are encouraged to come in costume; in fact, prizes are offered for the best costumes. People in period costume, seated in their cars, add greatly to the interest of the picture.

Jerry McGarry is an Audiovisual Specialist assigned to the Hollywood, California office of Kodak's Motion Picture and Audiovisual Markets Division. He provides information about Kodak audiovisual products and counsels on the planning, production, and presentation of audiovisual media. A native of Philadelphia, Jerry attended Temple University School of Communications, majoring in television production. Prior to joining Kodak, he had been a motion-picture director, studio owner, and an industrial audiovisual manager.

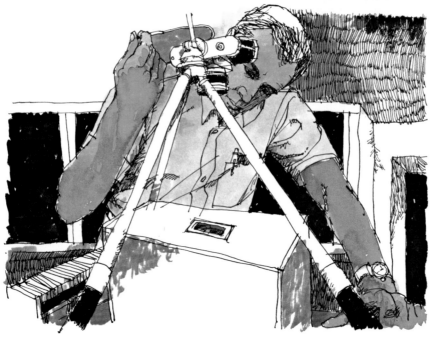

Slide-Duplicating Techniques
by Jerome T. McGarry

How many times have you toyed with the idea of making duplicates of some of your favorite slides? True, duplicates are readily available from your favorite photo dealer. But as with so many processes in photography, it's often more rewarding and more fun to do it yourself. Extra slides are useful as gifts, for swapping, or for repeating certain scenes in a show. When you duplicate your own slides, you can enlarge certain areas, improve poor exposure, or use filters to make color changes. You can even combine two or more images into a single new slide by making double exposures.

There are several ways of duplicating slides. I'm going to describe the methods that I think are the simplest and the best.* They are the following:

1. Photographing the image of the original slide from a normal front-projection screen.

2. Photographing the image of the original slide from a rear-projection screen.

3. Photographing the original slide by transillumination using photolamps, electronic flash, or a light box.

Before we get into specific techniques, let's take a look at some details that apply to all of the methods of slide duplicating.

THE CAMERA

A single-lens reflex camera is ideal for slide duplicating because it eliminates the parallax problem. If you must use a camera with a nonreflex viewfinder for close-up work, you may be able to install your own "ground glass." With the camera shutter open, open the camera back and place a piece of waxed paper, matte acetate, or frosted glass over the film plane. The image you see on the paper or glass is the same that will be recorded on the film.

WHICH FILM TO USE

For convenience, when I duplicate slides I choose a film to match the light source I'm using. This table will help you choose a film to match your light source. Of course, you may use other film-and-light-source combinations by following the filter recommendations on the film instruction sheets.

Some Recommended Films for Slide Duplicating

Film	Light Source
KODAK EKTACHROME Slide Duplicating Film 5038 (Process E-4)†	Photolamp (3200 K)
KODACHROME II Professional (Type A)	Photolamp (3400 K)
KODAK High Speed EKTACHROME (Tungsten)	Slide-Projector Lamp Photo-Enlarger Lamp (both approximately 3200 K) Photolamp (3200 K)
KODACHROME 25 (Daylight) KODACHROME 64 (Daylight) KODAK EKTACHROME-X	Electronic Flash Daylight

*You can also use these methods for making negatives from your slides. Unless the contrast of the slide is low, the contrast of the negative will be greater than normal.

†The shortest available length is a 100-foot roll. You can use short lengths in reusable KODAK SNAP-CAP 135 Magazines (available at photo-supply stores).

EXPOSURE TESTS

No matter which method of slide duplicating you choose, you'll need to make some exposure tests. Use a slide of "average" contrast and brightness for your tests. As I describe each duplicating method, I'll tell you how to determine the *basic* exposure. However, in *every* instance you should bracket your exposures at least 1 stop on either side of the basic exposure. When you see the processed slides, choose the best exposure and use this as the basic exposure for future dupes. If you duplicate other slides that are lighter than average, use a 1 stop smaller lens opening than your test indicated. Use 1 stop more exposure for duplicating slides that are darker than average.

Some people always bracket exposures of each slide, even after they've completed their exposure tests. That way they're always (well, almost always) sure of getting a dupe with an exposure that suits them "just right."

BEGIN WITH A CLEAN ORIGINAL

To help insure a spotless duplicate slide, keep the original as clean and dust-free as possible. Never touch a transparency with your fingers; handle mounted transparencies by their mounts, unmounted transparencies by the edges. Remove dust or lint particles from slides with a clean, dry, camel's-hair brush. You can remove light fingerprints or oily smudges by applying KODAK Film Cleaner sparingly with a plush pad or a wad of cotton.

Keep your original slide clean! Handle mounted slides by their mounts, unmounted transparencies by the edges.

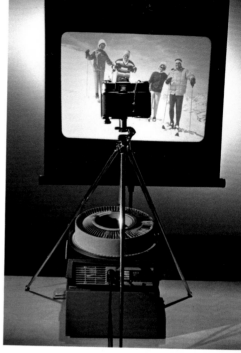

Position the camera as close as possible to the projection beam. If the focal lengths of the camera lens and projector lens are approximately the same, the tripod-mounted camera can straddle the projector.

PHOTOGRAPHING THE IMAGE FROM A NORMAL SCREEN

If possible, project the slide to be copied on a matte white screen. (Masonite or a similar material painted with several coats of flat-white paint is excellent and inexpensive.) Arrange the projector and the camera so that the camera is as close as possible to the axis of the projection beam. This will help avoid distortion in the dupe. If the focal lengths of the camera lens and the projector lens are approximately equal, you can set up the tripod-mounted camera to straddle the projector. (For example, a 3-inch projector lens and an 85 mm camera lens work fine in this manner.) If the camera has a shorter-focal-length lens (as is often the case), set it up in front of the projector, just under the projector beam. After you project the slide on the screen, you can move the camera back and forth to crop the picture any way you like. You can also crop the picture by using a longer-focal-length lens on the camera.

Work in a darkened room. Determine the basic exposure by taking a reflected-light reading from the projected image. Take an overall reading—hold the meter so that it doesn't shadow the screen or read the dark border around the image. Make a record of your test exposures and the projector-to-screen distance. For your exposure test to be useful, the projection distance must be the same each time you make a copy. The brightness of the image will change if the projection distance is changed.

COPYING FROM A REAR-PROJECTION SCREEN

In this method of duplicating slides, you use a translucent rather than an opaque screen. Place the projector behind the screen and photograph the projected image from the front. The slide must be reversed in the projector so that it will be properly oriented on the screen.

An excellent material to use as a rear-projection screen is a blackish translucent material called Lenscreen. It is available in single sheets from firms such as Polacoat, Inc., 9750 Conklin Road, Cincinnati, Ohio 45242, and Edmund Scientific Co., 380 Edscorp Bldg., Barrington, New Jersey 08007. Also, a 20 x 20-inch KODAK Day-View Screen (Part No. 762355) works well. You can send a price request and an order to Eastman Kodak Company, Central Parts Services, 800 Lee Road, Rochester, New York 14650. These rear-projection-screen materials are rigid and can easily be held in place with blocks of wood.

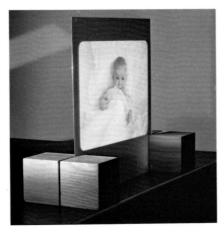

You can buy rigid rear-projection materials which are easily held in place with wooden blocks.

Another material that you can use for a rear-projection screen is matte acetate tacked or stapled to a wooden frame. Matte acetate is colorless, has a fine grain, transmits light well, and is less expensive than the special materials listed above. It is usually available through art-supply shops. The only disadvantage in using matte acetate is that the projected image appears brighter at the center, causing a "hot spot" in the center of the dupe. You can compensate for this effect by placing a "dodger" a few inches in front of the lens in the center of the projection beam. A half-dollar or similar-sized object glued to a piece of glass makes a good dodger. Adjust the dodger-to-lens distance until the projected image no longer appears brighter at the center.

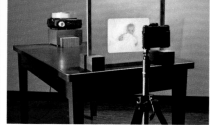

You can make a rear-projection screen by tacking or stapling matte acetate to a wooden frame.

When you use a matte-acetate rear-projection screen, the center of the projected image will be brighter than the edges unless you use a "dodger" in the projection beam. An easy-to-make dodger is a half-dollar glued to a piece of glass.

You can also use commercially available tabletop rear-projection screens for copying your slides. Most of these units include a mirror to orient the image, so it isn't necessary to reverse the slide in the projector.

Determine your basic exposure by taking an overall meter reading from the projected image. Alter the camera-to-screen distance to crop the picture. Always keep the projector-to-screen distance constant so that your exposure tests will be useful. Work in a darkened room to eliminate reflections on the surface of the screen.

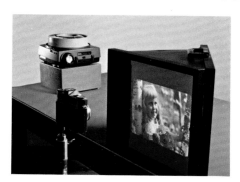

In this method of duplicating slides, you copy the slide directly, not the projected image. The camera should be equipped with a close-up lens (or lenses), extension tubes, or bellows focusing so that you can locate the camera close enough to the slide to make a one-to-one (same-size) copy.

When you use extension tubes or bellows, you must allow for the change in effective aperture. If you are making a one-to-one copy, either open the lens 2 stops more or increase the exposure time by a factor of 4. If you use close-up lenses, no exposure compensation is necessary. When you work at these short subject distances, use a lens opening of f/8 or smaller.

When you photograph a slide by transillumination, the light source can be a photoflood lamp, electronic flash, or a light box.

To copy a slide directly (rather than the projected image), you'll need close-up lenses, extension tubes, or bellows focusing.

Using a Photolamp (3400 K)

Set your camera on a tripod with an adjustable pan head so that the camera can be aimed straight down. For convenience, place your light near the floor (I prefer using a reflector photolamp in a clamp-on socket). Arrange a piece of diffusing glass, such as KODAK Flashed Opal Glass (available from photo dealers), several feet above the light. One simple arrangement is to turn a stool upside down and place two pieces of wood across the leg brace to support the diffusing glass. Another easy setup is to place two chairs back-to-back about a foot apart, and use the chair backs to support the glass.

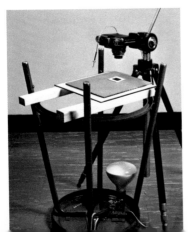

An upside-down stool makes a convenient slide-copying setup. The light source can be photolamp or electronic flash.

Next, cut an opening, slightly larger than the picture area of the slide, in a piece of cardboard. Lay the cardboard on the diffusing glass and position your slide over the opening. Work in a darkened room to avoid reflections on the surface of the slide.

If you place the light less than about 2 feet from the diffusing glass, position a heat-absorbing glass several inches below the diffusing glass. The heat-absorbing glass, usually available from plate-glass shops, will protect the diffusing glass and the slide from the heat of the lamp. Heat-absorbing glass may introduce a slight shift in color balance, which you can correct with filters. More about color correction later.

You can determine your basic exposure with an incident- or reflected-light meter. With a reflected-light meter, place the cell directly against the illuminated slide. The exposure indicated by the meter should be quite accurate if the meter cell is no larger than the slide area. If you use an incident-light meter, hold it so that the cell is in the position that the slide will occupy, but without the slide in place. Face the meter cell toward the light source.

Using Electronic Flash

The setup with electronic flash is basically the same as with photolamps. Place the flash unit behind the slide, pointed directly at the slide, and arrange a piece of diffusing glass (such as KODAK Flashed Opal Glass) between the flash and the slide. You will need a cord long enough to connect the flash unit and camera. Since electronic flash closely approximates daylight, use daylight-type color film and work in subdued room light.

I cannot suggest specific camera settings for good exposure because of the variety of flash units in use today. Make a test carefully with your equipment—about five or six trial exposures. Use a shutter speed of 1/60 second and aperture settings of f/4 to f/16. Place the flash 18 to 24 inches (for compact units) from the slide—for larger units, 36 to 48 inches.

Record the aperture setting used for each frame number. Measure and note the exact distance from the flash to the slide being copied. Remember, exposure will change as the distance is altered.

If your tests are all overexposed (too light), move your flash farther away or use another thickness of diffusing glass and repeat the tests. Of course, the opposite is true if they are all underexposed.

Using a Light Box

If you plan to duplicate quite a few slides at different times, you may want to build a special light box. Such a box offers the convenience of a standard copying setup. When you want to duplicate some

slides, just plug in the box and set up your camera.

Construct the box as illustrated below. While the dimensions are not critical, the box should measure about 10 inches square. Make the box from wood. The opening in the top should be large enough to illuminate the slides you plan to copy. If you expect to copy slides of different sizes, make the opening large enough to accommodate the largest slide. Then cover the opening with glass so you can lay smaller slides on the glass. Use a black opaque mask around the slide on the illuminator to keep stray light from reaching the camera lens.

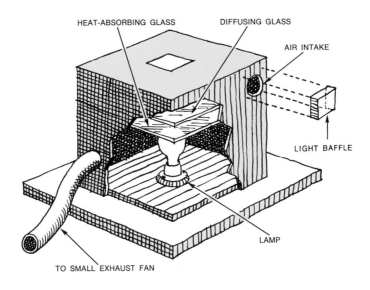

If you make one side of the box a hinged door, it will be much easier to replace the lamps when necessary. Paint the inside of the box with a matte white paint. Install a lamp socket in the center of the bottom of the box. You can use either a photoflood lamp or a photo enlarger lamp, No. 211 or 212. Make provisions for including a heat-absorbing glass and a diffusing glass (such as the KODAK Flashed Opal Glass) between the lamp and the slide. To allow air circulation, there must be some space between the sheets of glass and the sides of the box. You can best achieve this by using sheets of glass about ¾ inch smaller than the inside dimensions of the box. Tack small blocks of wood to the nonmovable sides of the box to support the glass.

Drill an air-intake hole above the diffusing glass, and another opening for an exhaust hose near the bottom of the box at the opposite corner. Make a light baffle for around the air intake out of a small box open on two adjoining sides. One open side will fit against the light box, and the other open side will face the base of the box. Attach a small exhaust fan, or even a tank-type vacuum cleaner, to the exhaust opening with a flexible hose. The flexible hose will help prevent vibrations from being transmitted to the light box.

Install a household dimmer switch in the wiring of the box so that you can reduce the brightness and heat while you position the slide and adjust the camera. *Be sure to switch to full brightness to take the pictures.*

Determine the basic exposure as described in "Using a Photolamp (3400 K)," page 96. Work in a darkened room to avoid reflections on the slide.

If you plan to duplicate many slides of equal size at one session, position the first slide and the camera, and mark the *exact* position of the slide with tape. This will make positioning successive slides easier, faster, and more precise. It will also allow you to accurately position several slides for making multiple exposures—a technique you can use to make titles or montages.

COLOR CORRECTION

Evaluate your duplicate slide by projecting it on a screen with your projector. If the color balance isn't the way you want it, you can make corrections when you re-shoot the original by placing KODAK Color Compensating Filters (called CC Filters) over the camera lens or between the slide and the light source. Don't use more than two filters over the lens, as the sharpness of the dupe may be impaired. You can use any number of filters between the slide and the light source. In fact, you can use the less expensive KODAK Color Printing Filters (called CP Filters) behind the slide. In this position, filters have no effect on the sharpness of the dupe.

To reduce a certain color, use filters of a complementary color when you re-shoot. (See the table on page 100.) You can judge approximately what effect a filter will have by looking through it at the projected image. The filters come in densities from .025 to .50. The density numbers are followed by letters indicating the color. For example, a CC20Y filter is a Color Compensating Filter with a density of .20, and it's yellow. In general, I think you'll use filters with a density of .10 to .20. The following table will help you choose filters for correcting color balance.

If the color balance is too:	Add these filters:
Cyan	Yellow and Magenta
Magenta	Yellow and Cyan
Yellow	Magenta and Cyan
Red	Cyan
Green	Magenta
Blue	Yellow

For *each* filter you use of either .10 or .20 density, increase the exposure by ⅓ stop.

PREFLASHING TO REDUCE CONTRAST

When you duplicate a slide, the dupe normally has more contrast than the original. Sometimes the added contrast is acceptable. But if you duplicate a contrasty original, the added contrast might be excessive. In this case, you can preflash the film to reduce the contrast of the dupe. In preflashing, the film is given a uniform exposure before the copy exposure is made. The preflashing exposure lowers the maximum density and the contrast of the shadows.

The most convenient method of preflashing is to expose the film to the same light source used for copying your slide, but without the slide in place. This exposure should be approximately 1/100 of the exposure for duplicating the slide. You can easily accomplish this by placing a 2.0 neutral density filter over the camera lens and making an exposure with the same lens opening and shutter speed that you'll use for making the dupe.

NOTE: When you use neutral density filters, be sure you don't confuse their density values. For example, a 2.0 neutral density filter reduces the light 100 times, while a .20 neutral density filter reduces the light by only 1½ times.

As with any unfamiliar procedure, make a series of test exposures to determine the best exposure for preflashing film.

For copying slides, I personally enjoy making my own slide-duplicating equipment. However, if you don't have the time or aren't interested in doing this, you can see your photo dealer about the many commercially made slide-copying devices which are available.

Slide duplication requires a little patience and practice. But after you've duplicated some slides and have seen the results, I believe you'll agree that slide duplicating can be both useful and creative.

John Paul Murphy, APSA, ARPS, FKCC, is a Photographic Specialist in Kodak's Consumer Markets Division. He is a past president of the Rochester International Salon of Photography, an International Salon judge, a photographic lecturer, a salon exhibitor, a former naval aviation and industrial photographer, and has earned many honors and awards for his photographic accomplishments. He holds a Bachelor of Science degree in Photographic Science and an Associate of Applied Science degree in Photographic Illustration from the Rochester Institute of Technology.

Imaginative Color Printing
by John Paul Murphy

Most of us began printing and enlarging with black-and-white materials. Black-and-white printing is important, challenging, and a lot of fun. Making color prints is even more rewarding. You're probably already interested in color printing and are making your own color prints, or you wouldn't be reading this article.* Rather than discuss the basics of color printing, I'm going to tell (and show) you how to give your color prints a shot in the arm. You might find that some rather ordinary pictures can become prizewinners, and that some of your prizewinners can become "best of show."

*If you want to brush up on some of the basics of color printing, you may want to look over KODAK Publication No. E-66, *Printing Color Negatives*. You can get a copy from your photo dealer. Or, if he doesn't have it, send $2.50 plus your state and local taxes to Eastman Kodak Company, Department 454, 343 State Street, Rochester, New York 14650. Be sure to specify title and code number.

When you make your own color prints, adding a dash of imagination can make your photographs more interesting and pictorial. When the finished print looks special because of some extra touch on your part, the whole process becomes more exciting. Imagine how drab a painting might be if the artist were forced to repeat exactly what he saw without heightening a shade, or rearranging the colors. His paintings might not be too exciting. In photography, too, there are times when you should deliberately emphasize colors for effect. Or, when the occasion arises, you can correct a color fault or blemish to make the scene appear more realistic.

You can do many imaginative things in color printing. Actually, the sky's the limit (not really, because I'm even going to tell you how you can change the color of the sky)!

DODGING AND BURNING IN

As a starter, let's consider this color photograph of a landscape in upstate New York, taken on a cold and wintry January morning. This is a straight print—I didn't use any controls when I made it. Not a bad picture, but what can be done to improve it?

First, the foreground is a little too dark. To lighten large areas such as this, "dodge" them during the basic exposure. Begin by determining the exposure for the overall scene. Then, during part of the basic exposure time, use a piece of dark cardboard to "dodge" the area you want to lighten. Don't hold the cardboard still—move it in and out so that the area you're making lighter will blend smoothly with adjoining areas (see figure 1).

To dodge smaller areas, use a small circle of dark cardboard (about the size of a half dollar) taped to a piece of stiff wire. If the area is just a little too dark, hold it back for about 10 to 20 percent of the basic exposure. Increase the percentage for those areas that need more lightening. In this picture I decided to dodge the foreground for about 20 percent of the basic exposure time.

How about the sun and sky in this picture? In the uncontrolled print, they weren't dark enough to give me the pictorial effect I wanted. I darkened them by burning them in after the basic exposure. To burn in the large sky area, I used the same piece of cardboard I used for dodging the foreground. After the basic exposure, I turned the enlarger on again but held the cardboard so that only the sky got additional exposure. When you burn in an area, the additional exposure is often one or two times the basic exposure. In this picture I burned in the sky for two times the basic exposure.

When the sky was dark enough, the sun was still a little too light. To burn in small areas such as this sun, use a piece of dark cardboard with a hole in it, as in figure 2. In the picture on the next page, I burned in the sun an additional three times the original exposure.

Fig. 1—Use dark cardboard to keep light from an area which is too dark—the same "dodging" technique used in black-and-white enlarging.

Fig. 2—Whenever you burn in or dodge, keep the cardboard moving slightly so that the controlled area blends with surrounding areas.

And there you have it—the finished print, showing the two primary controls—burning in and dodging.

Right now you may be thinking, "There's nothing new here that I haven't already done in black-and-white printing." You are quite right—all you need to do is start the ball rolling and try these techniques in color printing. Just use your black-and-white talents for color printing, and you'll be more than rewarded by your finished color prints.

SELECTIVE FILTRATION

How can you use the basic dodging and burning-in techniques for more advanced controls in color enlarging? Simply by manipulating filters. Look at the scene of a lonely pasture (page 105). What's this— a blue horse! Who ever heard of a blue horse? I guess you know how it happened. Some of this scene is in sunlight, but the horse is in shade and is illuminated primarily by light reflected from a blue sky. This is the sort of thing you may not notice when you snap the shutter,

but you'll certainly see it in your picture. Let's see what can be done to restore a more natural appearance to the horse.

I used the best filtration for the overall scene and dodged the image of the horse during the *entire* basic exposure. I cut a horse shape out of a piece of dark cardboard and taped it to a stiff wire to do the dodging. After I exposed the paper I changed the filter

pack to correct for the too-blue horse. Since I wanted to add yellow to the horse, I took yellow from the filter pack. In this particular instance I took CC20 yellow filtration out of the pack. Next I used the cardboard with the horse-shaped hole in it to expose the horse. (Remember, I dodged the horse for the entire basic exposure, so there was *no* exposure for the horse on the paper at this point.) My exposure for the horse was the same as the basic exposure. Sometimes the exposure for the controlled area (the horse, in this instance) will be more or less than the basic exposure. In addition to the times when exposure compensation may be required for the different filtration, there will be times when you may want the controlled area lighter or darker than it was in the uncontrolled print.

And that's the end of the blue-horse problem. Incidentally, sometimes you will have to make a compromise, just as I did in this print. There is still some blue remaining in the image of the horse. If I had removed all of this blue area, the rest of the horse would have been too yellow.

CHANGING OVERALL COLOR BALANCE

Now let's really let the imagination run wild! Here are five renditions of one scene—an icy winter snowscape. By changing overall filtration, you can make a picture look as though it was taken at different times of day. The yellowish cast of the first picture gives it a sunrise look, doesn't it? All I did was remove yellow from the basic filter pack. (As you know, removing a given color from the filter pack *adds* that color to the print.) The second picture looks more like midmorning on a cold winter day. Then I made the third, reddish rendition because I wanted a sunset print. If you want a moonlight shot, make a cyan or bluish print such as picture 4 or 5. You be the judge—some people

like all five prints—others have a specific preference. The important thing is that you can have your choice because you have complete control over the results.

Incidentally, this picture was really taken in the late afternoon.

1

2

3

4

5

USING *KODAK* RETOUCHING COLORS

There are some things that you can do to improve your color prints after the darkroom work is done. Before I began working on the print of fall foliage below, all the leaves on the ground had the same drab, brownish color that you can still see in the leaves on the right-hand side of the print. This is an example of how you can add color to small areas of your color prints by using KODAK Retouching Colors. You can apply the colors with a spotting brush. (I used a No. 2 KODAK DeLuxe Spotting and Coloring Brush.) Use a moist brush, and just apply the dyes until the print looks the way you want it to look. To make the colors permanent, hold the print over steam for a few seconds. (Don't overdo it—the steam from an electric vaporizer is adequate.)

You can add color to small areas of your color prints by applying KODAK Retouching Colors with a brush.

You can use a ball of cotton to apply KODAK Retouching Colors to larger areas of your prints.

You can use retouching colors to improve larger areas, too. In the picture of the lighthouse on the preceding page, the rocks were lacking in color. They were quite pale and drab. You can add color to larger areas such as this by applying retouching colors with a ball of cotton. Apply the color dry, right from the container. You may need to use another ball of cotton to smooth the colors out. If you "bleed" color into an area where you don't want it, simply wipe off the dye before fixing it with steam.

You can increase the intensity of the color by alternately applying steam and more color. The steam will fix the color already on the print and allow you to add more density and color.

These pictures of a small girl reading a book in the wicker chair are good examples of how you can increase color saturation by applying retouching colors. In the picture on the right, I added yellow to the chair and red to some areas of the little girl's pajamas to increase the color saturation.

There is one important point to remember when you apply KODAK Retouching Colors. They are translucent, so they do not completely cover the color underneath. This means that you can't use these colors to change red to blue, for example. But as you've seen, retouching colors are quite useful in putting color where color isn't or in increasing the saturation of a color.

Your own imagination is the key—be sure to use it!

John Schroth is a member of Kodak's Motion Picture and Audiovisual Markets Division. In his counseling of business and professional groups on the effective use of audiovisual techniques, John continually works with the techniques about which he teaches. As a former training-staff specialist and evening-college instructor, he has had wide experience in the planning and execution of numerous courses for Kodak and for other organizations.

How to Produce a Slide-Tape Talk
by John F. Schroth

What people see influences them. So does what they hear. Put sight and sound together in a well-planned slide-tape program, and you have a powerful tool for educating, entertaining, and influencing an audience. Our goal here is to tell you how to do this well.

The important first step to take in planning a slide-tape program is to decide what you want the program to do: Entertain friends with the story of your trip? Convince people to support a fund drive for a local hospital? Train people to drive safely? Whatever your goal, you must know your audience and appeal to its personal interests and background.

GATHERING IDEAS

Begin by deciding what you must "say" to reach your goal. At this stage, a "brainstorming" session is good (even if it involves only you), because each idea often generates new ones. During such a session, a teen-age diplomat would think of all the things the folks at home might want to know about the countries he will visit. A civic group promoting urban renewal would jot down every problem of the inner city.

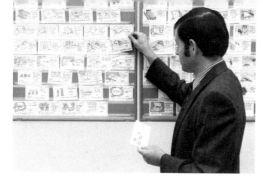

A planning board is useful for organizing your idea cards and for planning your entire program. For information concerning ready-made planning boards and printed cards, write to Medro Educational Products, P.O. Box 8463, Rochester, New York 14618.

Write down all of your ideas on small cards; then organize the cards. You can use a planning board, as illustrated above. *Audiovisual Planning Equipment,* KODAK Pamphlet No. S-11, includes instructions for making a planning board. A single free copy is available from Eastman Kodak Company, Department 412L, 343 State Street, Rochester, New York 14650. Of course, if you don't have a planning board, a table will serve the purpose, too.

The next step is to group your cards. Each group will be like a chapter of your story—each card a paragraph within the chapter. Then arrange the cards in the best sequence to tell your story. For example, the teen-age diplomat could have a group of cards for each country—each card might represent something of interest in that country.

Consider program length. Few people can hold the attention of an audience for more than an hour. Try to get your message across effectively in a half hour or less.

You can edit your story at this point by changing the position of some of the cards within a group, or even the position of entire groups. You may decide to throw out some cards because they contain unimportant or irrelevant data. When the editing is done, you'll have a well-organized flow of ideas which leads to your goal. The organized cards are your guides in planning both your pictures and your narration.

PLANNING THE PICTURES

In a slide-tape talk, pictures carry the lion's share of the communication load. For pictures to tell a story, they must be interrelated and the series must have continuity (such as the series on print-mounting shown on pages 123 and 124 of this book). Since pictures are the basis of your story, they must be done first. The words come later and serve to round out your message and tie it together.

The amount of detail you put into planning your pictures is your decision. Some people in the "presentation business" insist on very complete planning of pictures and words before a single picture is made. These people use the planning-board approach to decide

Some people like to decide precisely what each slide will show before any pictures are made. Using planning cards is a good way of planning your pictures.

exactly what pictures they want. This approach isn't to restrict the photographer. It's simply to tell him *specifically* what pictures are required and where the emphasis must lie.

A much less detailed approach is called "planning in the camera." The photographer knows the story but works with a written outline—not a detailed treatment. He takes the pictures he thinks will do the job best. When the entire production is a one-man job, the "planning-in-the-camera" approach is the one most frequently used.

TAKING THE PICTURES

Your slides should be simple, understandable, and legible. Using different angles and intermixing long, medium, and close-up shots adds variety. Use different slide formats, too. Masks such as those shown on page 114 are commercially available for cropping or giving a new shape to your slides.

If you want help in picture-taking, see your photo dealer. He has KODAK Publications on all phases of photography. For help in making and using titles effectively, read "Titling Techniques" in *More Here's How,* KODAK Publication No. AE-83. Or read *Simple Copying Techniques with a KODAK EKTAGRAPHIC Visualmaker,* KODAK Publication No. S-40. A single free copy is available from Eastman Kodak Company, Dept. 412L, Rochester, New York 14650.

It's better to shoot too many pictures than too few. This gives you a choice of pictures—but be unmerciful to yourself (and most merciful to your audience) by selecting only the pictures you need to get the point across.

After most of the slides are made, an illuminator is a big help in editing and arranging them. The pamphlet *Audiovisual Planning Equipment,* mentioned earlier, contains instructions for making an illuminator. You can use 2 by 2-inch cards to represent any pictures still to be made. Label the cards to indicate the pictures that they represent.

An illuminator is useful for editing and arranging your slides. You can build your own illuminator, or you can buy one from your photo dealer.

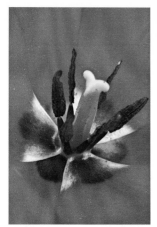

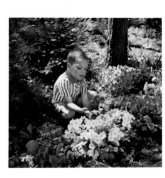

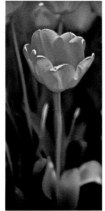

The variety you get by shooting pictures from different angles and distances, and by using masks, helps keep your program dynamic.

114

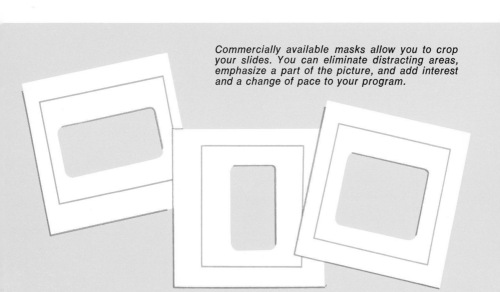

Commercially available masks allow you to crop your slides. You can eliminate distracting areas, emphasize a part of the picture, and add interest and a change of pace to your program.

THE WORDS

Your narration ties the pictures together, puts emphasis where you want it, and rounds out your story. The best narration won't call attention to itself—it will be simple, brief, and to the point. Your pictures will carry most of the communication load.

Don't explain the obvious. How often have you heard things like, "And here's a picture of little Johnnie washing the dog." We know it's a picture; it has to be Johnnie; and cats just don't look like that. On the other hand, some points can be handled nicely with words. If you want people to know the population of Rocky River, Ohio, just tell them what it is. It isn't necessary to photograph a sign showing the population figures.

Begin preparing your narration by making notes for each picture. Using these notes, talk through the slides to get the feel and pace of your program. Record and play back your run-through. Listening to yourself helps you find spots that need polishing. Run-throughs also test the continuity of your pictures, and help you with any final picture editing that may be necessary to achieve the pace you want. If your narration seems awkward, confusing, or involved, you may need to change the sequence of some slides, delete a few, or add some new ones to make points you overlooked.

When the words and pictures flow smoothly, write out the working script. Your first script will not contain cue marks, but when completed, your script will be similar to the one illustrated below. It should contain the following:

1. Slide number and brief description of each slide

2. Narration for each slide

3. Cue marks to show slide changes

4. Cue marks indicating where background music and sound effects will be used

Slide	Subject	Narration	Background Music and Effects
43	Town from church tower	During the summer, the town I lived in celebrated its 800th anniversary. ●	
44	Long shot of parade	The festivities opened ✱ with a parade of floats. Each one depicted an important era in the town's history—	Fade in march music
45	Float close-up	. . . from the days when it was inhabited by Teutonic tribesmen . . . ●	
46	Float close-up	. . . to the war with the French . . . ●	
47	Float close-up	. . . to relatively modern times and the founding of the chemical plant. ✱	Fade out march music
48	Group shot of me with "family"	Experiences like these ● helped me to know and better understand the wonderful people with whom I spent my summer, especially my German "family."	

In this sample script, the cues for slide changes are large dots made with a felt-tip marking pen. The music and sound-effects cues are large asterisks, with an explanation of the cue in the right-hand column. 115

CUING FOR SLIDE CHANGES

A slide flashing on the screen at "just the right moment" can mean the difference between a strong point well made and just another point. Good timing is important. It helps the program move briskly and keeps the words and pictures in good synchronization. The moral—be sure the cue marks for slide changes are accurately marked on your script.

Run through your program several times to become thoroughly familiar with the script and the sequence of the slides. Then ask someone to follow along with a second script to mark the exact place where you push the button to change slides. For split-second timing, you must push the advance button slightly ahead of the time when you want the slide to appear, because of the mechanical time lag.

The best time for a slide change may be right in the middle of a sentence. Project each slide only long enough for the information to register—no longer. This means different timing for different slides. Variety such as this helps keep the show interesting and dynamic.

MUSIC AND OTHER EFFECTS

Background music and sound effects add further variety and interest to your show. Background music should support your pictures—almost without being noticed. Match your music to your pictures. Choose music that helps put your audience in the mood you want.

It's a good idea to use music recorded and legally cleared for public use. (Firms from which background-music and sound-effects records are available are listed under "Music—Background" in the yellow pages of telephone directories in larger cities.) This avoids problems due to copyright laws and other legal restrictions. Also, music that is familiar to your audience may draw attention from your story.

You may want to use a single musical theme throughout your presentation to bind it together. However, to change pace or mood, choose several different musical selections. Repeat a selection if it isn't long enough to cover a complete section of the show. You may also repeat a selection to help tie the mood and content of one section of the show to that of a similar section.

CUING FOR BACKGROUND MUSIC

Decide where you want a musical background and what selections you're going to use. Run through your program and mark the places on the script where music should begin and end. If you have sound effects that you recorded "on location" or that you plan to lift from sound-effects records, mark their locations on the script, too. To be sure that the music or sound effects fit the mood and the space allowed, try them out. If you want to gain impact by having certain bars of music emphasize certain words and pictures, time the music

and the dialogue so that the emphasis comes where you want it. If you need a section of music without narration, you can record the music on a separate tape and splice it into your narration tape. It will take several dry runs before you'll be ready for a smooth recording session.

METHODS OF RECORDING NARRATION PLUS BACKGROUND

The easiest way to record narration and background simultaneously is simply to have the background sounds playing as you narrate—both are recorded at the same time through one microphone. Music and sound effects should originate some distance from the mike, so it's best to have a helper operate your playback equipment (tape recorder or phonograph). If you don't have a helper, keep the playback equipment within reach but use an extension speaker. The quality of the background music depends greatly on the speaker quality.

You can fade music and other effects in and out by adjusting the volume of the playback equipment. If you're using a directional microphone, you can fade the background sound in and out by turning the mike toward and away from the sound source.

Another method of recording voice and background together is to feed both the microphone and playback machine into a mixer that feeds into your tape recorder. Control the volume of each source with the gain controls on the mixer. Use monitoring headphones to get the balance you want. If you don't have headphones, a few trial runs will do the trick.

If you have a stereo tape recorder, you can record the narration and background on separate tracks. The advantage—you can make changes in one track without affecting both. If you want to combine the tracks later, feed the output of both channels into a single channel on a second recorder.

GETTING READY TO RECORD

For the live recording session, then, you need this equipment:

1. Slide projector, with slides in order and ready to show
2. A projection screen (or wall)
3. Tape recorder, with mike and enough tape for the entire program
4. The script, cue-marked for slide changes and other effects
5. Playback machine or mixer if you plan background music or special effects
6. Music and sound effects on tape or phonograph records

If your slide projector operates by remote control, place it far enough from the mike so that you don't record the operational sounds

You can make a mike box to help eliminate unavoidable noises, such as those made by car horns and barking dogs. Line the box with a thick felt padding. This box has an adjustable "T-bar" on top to help the narrator maintain the recommended distance from his microphone.

of the projector. Placing the projector beyond an open door in another room is a good idea—just so you can see the projected slides.

The mike should always be on a table by itself so that it won't pick up vibrations from other equipment. You can make a simple box to squelch those sounds you can't avoid, such as blasts from car horns, etc. The box must be open on one side, big enough to hold the mike, and lined with sound-absorbing material (thick felt padding is good). Place the mike in the box and speak into the open side. (Use this box system only if you don't plan on mixing voice with background via one microphone.)

RECORDING

Your script controls the entire operation. It contains the narration and cues for slide changes and background effects. If you record only a section at a time you can listen to your results to be sure all is well. (The break isn't a bad idea for you, either.) When you're using background music, stop at the natural pauses in the music so that your breaks aren't noticeable.

SYNCHRONIZING SOUND AND SLIDES

One simple method of synchronizing sound and slides is for the projectionist to change slides by following the cues on the script while listening to the tape. Another approach is to use audible cues recorded on the tape. No doubt you're familiar with the beep tones sometimes used to indicate a slide change. Unfortunately, the beep tones may detract from the presentation. If you use audible cues, pick the least distracting sound—like the tap of a pencil.

The smoothest, most professional show has inaudible cues on the tape that automatically change the slides. Several tape-recorder-projector synchronizers are available (through stores specializing in audiovisual equipment) which trigger the advance mechanism on slide projectors in response to cue marks you put on the tape. Only projectors with remote-control outlets can be used, because the synchronizing equipment operates the projector via its remote-control

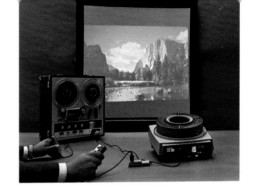

A KODAK CAROUSEL Sound Synchronizer, Model 3, is ideal for synchronizing a stereo tape recorder with KODAK CAROUSEL and EKTAGRAPHIC Projectors with remote-control outlets. During recording, the sound is taped on one track, and each slide change records a signal on the second track. On playback, the signal advances the projector.

outlet. The KODAK CAROUSEL Sound Synchronizer, Model 3, teams up admirably with many stereo tape recorders and KODAK CAROUSEL and EKTAGRAPHIC Projectors with remote-control outlets.

If you produce an automatically synchronized slide-tape program, keep in mind that all users may not have a remote-control projector with automatic synchronization. So always include a script that is cue-marked for slide changes when the program is sent out to other users.

A FEW VARIATIONS

A combination tape-live program sometimes makes an interesting presentation. Live narration can be interspersed with a recording. This is easy if you are giving your own program, but even if someone else presents it, part of it can be given "live" from the script. If you give the show yourself, the live part can be a question-and-answer session at the end. If the program is all on tape, using two people for narration adds variety and a change of pace.

Producing a slide-tape talk is a real challenge. You creatively and effectively combine the power of pictures and sound to tell a meaningful story. The reward comes when your audience reacts in the way you planned. This is communication with a purpose. You can really put your slide presentation into a class by itself if you add motion pictures (super 8 or 16 mm) at strategic places. Stills are great for many situations, but sometimes the realism and impact of a short film is the best way to convey your idea.

Audio-Visual Library Distribution of Eastman Kodak Company circulates by mail many free programs on all phases of photography. Many of these programs are slide-tape programs. If you're interested in seeing how such programs are put together (and in picking up some pointers on photography at the same time), you can obtain a complete list and description of the programs by writing to Eastman Kodak Company, Photo Information, Dept. 841, 343 State St., Rochester, New York 14650. Ask for *Your Programs from Kodak,* KODAK Publication No. AT-1.

Paul D. Yarrows, FPSA, FRPS, Hon. FPSSA, is a Program Specialist in Kodak's Consumer Markets Division. For several years, Paul has ranked among the top amateur photographers in the world, with more than 3,000 acceptances in international exhibitions. Paul is the first person to hold three 5-star ratings in the Photographic Society of America in color, black-and-white, and nature photography. His imaginative photographic lectures have been enjoyed throughout the United States and Canada.

Print-Finishing Techniques
by Paul D. Yarrows

After you remove your photographic prints from the wash water, anything that you do to enhance them is a print-finishing technique. When you've made an exciting shot and produced the best possible print, you can add the final touches by practicing good print-finishing techniques. These techniques can mean a blue ribbon in competition or a fine-quality photograph to display in your home or office. Here are the print-finishing techniques I use for KODAK EKTACOLOR 37 RC Paper and for resin-coated and conventional paper-base black-and-white prints.

RESIN-COATED VS CONVENTIONAL PAPER-BASE PRINTS

Resin-coated and conventional paper-base photographic papers have different characteristics and therefore require different finishing techniques. For instance, resin-coated papers absorb less of the pro-

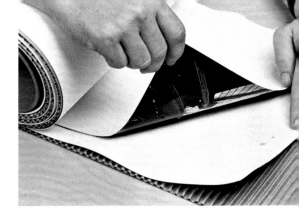

Using a KODAK Photo Blotter Roll is a convenient way of drying matte-finish paper-base prints.

cessing solutions than do conventional paper-base papers. Therefore, resin-coated papers require less washing and can readily be air-dried in a short time. Throughout this article, differences in the finishing techniques for the two types of papers will be pointed out.

DRYING MATTE-FINISH PRINTS

If you're making matte-finish prints, remove excess moisture (as well as any possible sediment) by wiping the emulsion with a soft moist sponge or a KODAK Photo Chamois. This speeds drying and helps prevent water spots, rippled edges, and uneven drying.

An easy way of drying paper-base prints to a matte finish is by using a KODAK Photo Blotter Roll. Just place the prints, face down, on the blotter and roll it up. The corrugated cardboard permits air circulation to speed drying. Another method of matte-drying paper-base prints is to stack the prints between muslin-faced blotters (available from photo dealers). Resin-coated prints should never be dried by either of these methods.

Resin-coated prints will air dry in minutes if placed on a table or counter. There is relatively little curl with air-dried resin-coated prints.

Sometimes paper-base prints may curl when they dry. This is particularly true in the winter when the relative humidity is low. Under these conditions the emulsion dries so completely that it shrinks

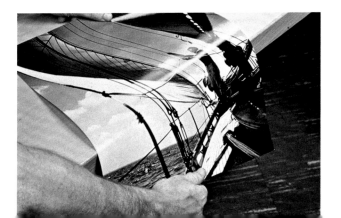

You can minimize curl in paper-base prints by pulling the print, emulsion side up, across the edge of a table.

121

more than the paper and pulls the print into a face curl. Any of the following procedures will help minimize curl:

1. Pull the print, emulsion side up, across the edge of a table, as illustrated below. Be sure you don't make any sharp bends in the print which could crack the emulsion.

2. Dampen the back of the print very slightly with a moist sponge and put it under weight. The emulsion side must be dry and should be resting on a clean, dry surface.

3. Soak the print in KODAK Print Flattening Solution, then dry it in your usual way.

FERROTYPING

Ferrotyping is the process of giving a high gloss to your paper-base prints by pressing the emulsion against a smooth surface during drying. The high gloss increases the richness of blacks and increases the apparent tonal range of the print. You must make your prints on smooth-surface papers (such as Kodak paper-base papers with an F surface) if you plan on ferrotyping them. *Do not ferrotype resin-coated prints, regardless of the surface.*

You can buy special ferrotype tins. There are two types in general use: black japanned tins and chrome-plated tins. If you use a black japanned tin, treat it periodically with ferrotype plate polish. This keeps it clean and helps prevent the prints from sticking.

If you use a chrome-plated ferrotype tin, polish it occasionally with Bon Ami soap cakes (*not* the spray or powder). You can also use glass wax or Nu Steel No. 1 all-purpose cleaner and polish. Allow the cleaner to dry; then wipe it off. You should be able to draw your finger across the tin without picking up the polish. These cleaning agents not only clean chromium plates but also deposit a thin layer of fatty acid that makes it easier to remove the prints when they're dry. (Do not use these cleaners on japanned tins.)

When you ferrotype a print, you must have a layer of water without air bells between the print and the tin. So, while the print is still in the water, wipe it with your hand to remove any air bells clinging to

Use a squeegee to press the print against the ferrotype tin and to remove excess water.

Your final step in ferrotyping is placing a blotter over the print and rolling it firmly against the tin.

the emulsion. Also, rinse the tin and swab it thoroughly with your fingertips.

Lift the print from the water by two adjacent corners. Hold it over the tin and lower it gradually so that the emulsion side of the print "rolls" onto the ferrotyping surface. Remove excess water with some type of squeegee. The straight-edged "window-wiper" type works well. Squeegeeing also pushes the print into firm contact with the tin. Then press a blotter sheet over the back of the print to pick up any water still present. Leave the blotter over the print and roll the print firmly against the tin with a roller, such as the KODAK Master Print Roller. Then remove the blotter and leave the print on the tin until the print dries and pops off by itself.

MOUNTING

A mount disassociates a picture from its surroundings and consequently emphasizes the picture. A well-chosen mount calls attention to the picture, not to itself. Most photographers use a material such as KODAK Dry Mounting Tissue, Type 2, for mounting their prints. This is the way it works:

1. Tack the tissue to the back of the print, using a tacking iron or a household iron (set the iron at the lowest setting in the synthetic fabrics range and adjust if necessary).

2. Trim the print.

1.

2.

123

3.

3. Position the print on the mounting board. Holding the print in place, lift one corner of the print and tack the mounting tissue to the mount. Do this on each corner.

4. If you have a dry-mounting press, put the print into the press and protect the print with a double thickness of heavy kraft wrapping paper which has been dried in the hot press. Any moisture in the paper could cause it to stick to the print. Then close the press for at least 30 seconds. The temperature of the press should be between 180° and 210° F.

4.

5. If you don't have a mounting press, use a household iron to mount your print. Cover the print with kraft paper, as mentioned above, and run the iron back and forth over the print. Keep the iron in motion and work from the center of the print toward the edges. Don't push down too hard, or you may mar the surface of the print. Use the same settings on the iron as suggested in Step 1 for tacking the tissue to the print.

5.

6. When you dry-mount prints by using a thermo-adhesive mounting tissue, such as KODAK Dry Mounting Tissue, Type 2, *immediately* place the mounted print face down under a heavy flat object that is larger than the mounted print, such as a smoothly finished piece of plywood with heavy books placed on top. This will help to provide better adhesion.

NOTE: Of necessity, the mounting procedure outlined here is general in nature. For specific details, read the instructions that come with the mounting tissue.

It's a good idea to mount a few reject prints for practice before you attempt to mount an important photograph.

You may also mount your print by using a photographically inert cement, such as KODAK Rapid Mounting Cement. Rubber cement

Gray or black underlays can be quite effective with black-and-white or color prints.

When tastefully used, color underlays also dress up color prints.

can be used on resin-coated prints; however, it isn't recommended for conventional paper-base prints. With prints made on resin-coated paper, if the surface of the mount is nonporous, use double-faced adhesive tape or a contact cement.

Underlays dress up a print, too. To mount a print with an underlay:
1. Tack the mounting tissue to the print. Trim off the excess tissue.

Overlay mounts are easy to use. They are good for displaying prints at home and for temporary mounting.

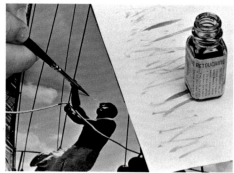

To eliminate white spots, apply dyes by using a brush in a stippling motion until the spot disappears.

2. Tack the print to a piece of art paper slightly larger than the print.
3. Tack mounting tissue to the art paper and trim the excess tissue.
4. Tack the art paper to the board.
5. Mount the print with a mounting press or a household iron.

You can buy *overlay* mounts in art or photo-supply stores. There's no actual mounting involved when you use an overlay. Just lift the overlay and slide the print into place. Then tape or glue the bottom corners of the print to the mounting board. While these mounts are fine for temporary or home use, they usually aren't acceptable for photographic contests or salons.

SPOTTING

Despite all the precautions you take against dust and dirt, most prints end up with at least a few white spots. You can fill in the spots by using dyes and spotting brushes. Brushes with fine points suitable for spotting are available at art-supply stores. No. 00 or No. 0 sizes are usually the most useful. KODAK Spotting Colors, for matte black-and-white paper-base prints, are dry dyes supplied in a set of three colors: black, white, and sepia. Another type of spotting dye for black-and-white prints is a liquid called Spotone. You can spot color prints with colored dyes, such as KODAK Retouching Colors or Webster Retouching Set dyes.

To spot your prints, dampen the spotting brush slightly and pick up a little spotting dye of the right color on the tip of the brush (you can mix colors if necessary). Rotate the brush to make a fine point. Apply the dye to the spot with a dotting or stippling motion until the dye matches the tone of the surrounding area—and the spot is no longer visible. It's best to begin with dark areas and work on lighter areas as the dye works out of the brush. If the dye bubbles when you apply it, the brush is too wet.

ETCHING

Now and then one of your prints may have a dark spot. You can eliminate such spots by etching them with a good-grade surgical steel knife, such as the KODAK Etching Knife.

The first time you do any print etching, start with a scrap print for practice. Scrape the emulsion very lightly with the knife—don't dig it. Unlike spotting, which should be done after ferrotyping, etching should be done *before* ferrotyping because it disturbs the print surface.

PROTECTING THE PRINT SURFACE

You can protect prints by spraying the surface with a clear protective spray, such as Krylon and Getzol protective sprays, available in a matte and in a glossy finish. Practice spraying on an extra print. Hold the spray can about a foot from the print and spray with an even, sweeping motion. Repeat the process if the first coat doesn't cover. If you apply too much spray at one time, the print surface will have an "orange peel" texture.

You can protect the surface of prints by spraying them with a glossy or matte protective spray.

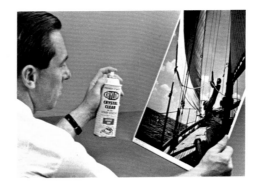

TITLING

Printing the title of your photograph and your name just under the print adds the finishing touch. Keep the title short and simple. Ideally, the first letter of the title should start even with the left edge of the print. Print your name in the lower right corner to match the title. The last letter of your name should be flush with the right edge of the print.

When you enter prints in photographic salons or camera-club competitions, print all the required information on the back of the mounting board in the upper left corner. Include your name, address and the title of the print.

As you begin trying these print-finishing techniques, I'm sure you'll find them quite rewarding. After a little practice, I believe you'll be so pleased with the results that you'll probably be "hooked"—like I am.